Cranes, Herons & Egrets

THE ELEGANCE OF OUR TALLEST BIRDS

BY STAN TEKIELA

Adventure Publications
Cambridge, Minnesota

DEDICATION

To my lovely daughter, Abby, with all my love.

ACKNOWLEDGMENTS

The following people and organizations have been instrumental in obtaining some of the images in this book. For all that you do, thank you.

Agnieszka Bacal • Debbie Cohn • Jeff Grotte • Marcus Hammitt • Paul Musegades • Doug Pellerin • Karen Krull Robart • Keith Sjostrom • International Crane Foundation • Operation Migration

Special thanks to Rick Bowers, wildlife biologist and extraordinary friend, for reviewing this book. I am continually impressed and amazed at your in-depth knowledge of birds.

Cover photos by Stan Tekiela
All photos by Stan Tekiela except pg. 110 by Marcus Hammitt and pg. 115 by Agnieszka Bacal.

Edited by Sandy Livoti
Cover and book design by Jonathan Norberg

Copyright 2016 by Stan Tekiela
Published by Adventure Publications
820 Cleveland Street South
Cambridge, Minnesota 55008
1-800-678-7006
www.adventurepublications.net

TABLE OF CONTENTS

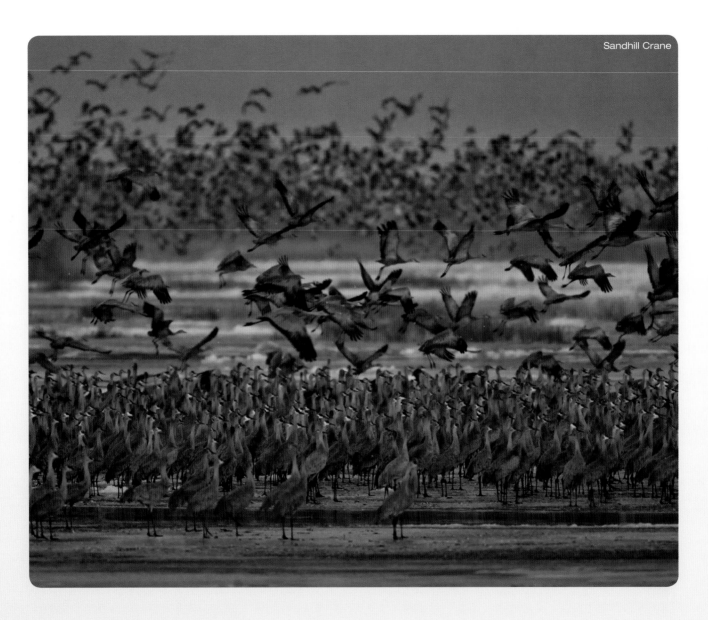
Sandhill Crane

I have always been fascinated with birds—all birds! But, about 30 years ago, I heard a public radio host speak about visiting south central Nebraska in spring to see the migration of hundreds of thousands of Sandhill Cranes. I listened intently to the vivid descriptions of these magnificent birds and tried to imagine what it would be like to witness the event for myself. This migration has been rated as one of the top five natural events in the world, and, right then and there, I decided to make the pilgrimage to the Platte River to experience this annual rite of spring.

The following year, I packed my truck and headed out. What I saw truly *was* one of the most amazing wildlife spectacles in the world! Over a half-million cranes visit the Platte River, all during a short window of four to six weeks in spring. This is easily comparable to the mass migration of caribou in Alaska and the Yukon or the migration of wildebeests in Africa. Ever since this encounter, I've been seeking out cranes across North America, often traveling hundreds of miles to observe and photograph them.

If the Sandhill Crane is the main event, then the Whooping Crane has to be the highlight! The tallest bird in North America, this majestic creature was nearly driven into extinction. Through many concerted efforts, it was reintroduced, and now several populations occur in the United States and Canada. These small migratory populations have grown over the years and now include up to about 250 individuals.

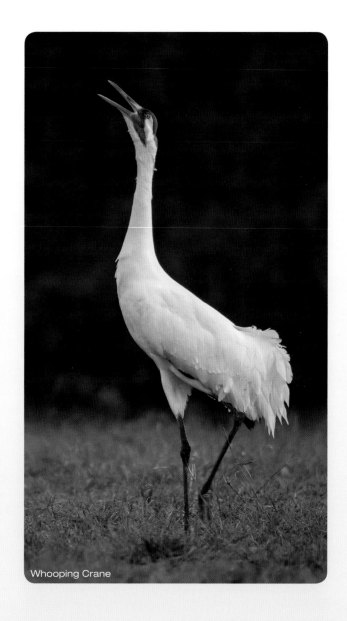

Whooping Crane

GRACEFUL HERONS AND EGRETS

Herons and egrets are not only elegant and beautiful, but they are also some of the easiest of all birds to see and identify. In many parts of the United States they can be fairly common. While they may be familiar birds, they are nonetheless stunning and a pleasure to behold.

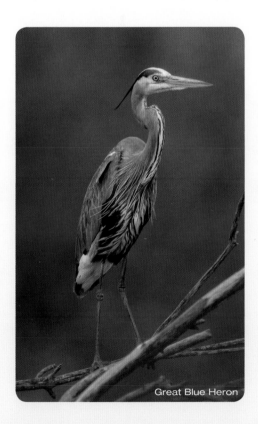

Great Blue Heron

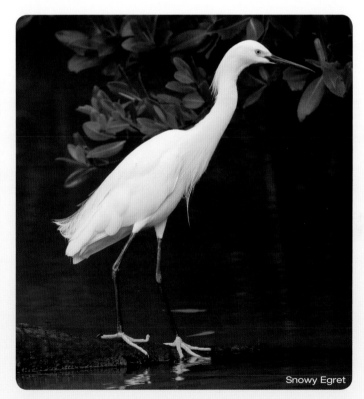

Snowy Egret

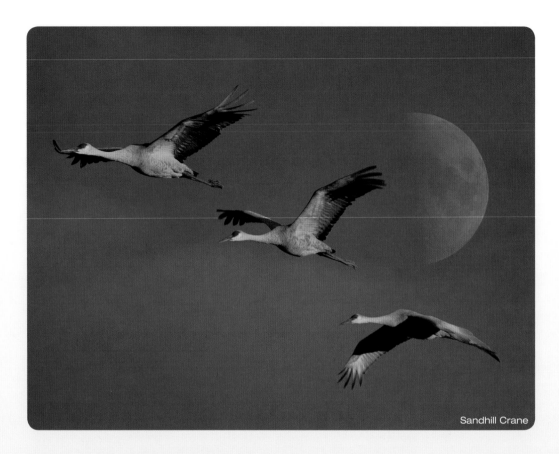
Sandhill Crane

REMARKABLE THROUGH THE AGES

Sandhill Cranes are quite possibly one of the oldest known bird species. Fossilized wing bones found in Nebraska date back 10 million years, and scientists think these finds belong to a remarkably old crane species that may be closely related to our modern Sandhill Cranes. Perhaps even more amazing are Florida's crane fossils, which date back 2.5 million years. These are clearly the same Sandhill species of today. It's exciting to think about how long these magnificent cranes have been flying over North America!

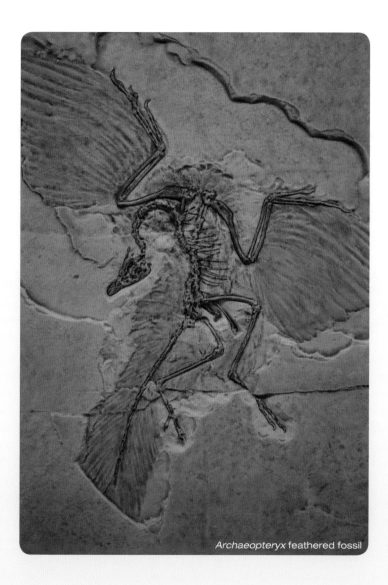
Archaeopteryx feathered fossil

Bird fossils are not that common because a bird's fragile feathers and thin, hollow bones don't fossilize well. Regardless, it is clear that birds similar to our modern herons and egrets first occurred about 7 million years ago, making them a very old group of birds as well. Around 1–2 million years ago, the herons and egrets that are known today emerged and evolved into the species we see in our local wetlands.

HISTORY OF BIRD FEATHER FASHIONS

Herons and egrets have had an unfortunate history with people. Due to fashion trends from the late 1800s to the early 1900s, hunters killed many birds just for their feathers, mostly to adorn women's hats. Between the 1870s and mid-1920s, tens of millions of herons and egrets were killed to meet the demand for their ornate breeding plumage. Market hunters targeted heronries, where often hundreds of adults nested with their young, and killed all the parents. The babies were left to fend for themselves, usually with disastrous results.

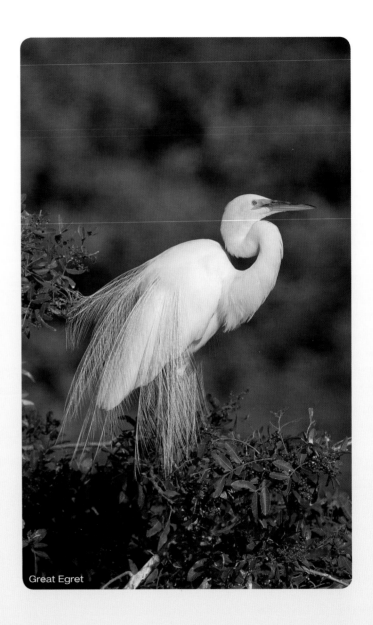

Great Egret

Many of the herons and egrets we appreciate today, such as Tricolored Herons, Great Egrets and Reddish Egrets, were almost hunted into extinction. This outraged a lot of people, and U.S. and Canadian conservation groups started forming.

When heronry slaughtering became public knowledge, people demanded legal protection for the birds. Several federal laws were passed, and many more laws were enacted between 1900 and the 1930s. Around the same time, fashions changed and the demand for feathers faded away. Many of these laws are still in effect today and protect non-game species. This is why it's illegal to own many types of non-game species feathers. Preventing new demands for feathers, these laws are often strictly enforced.

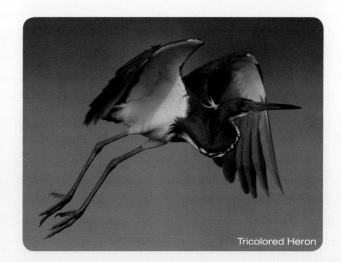
Tricolored Heron

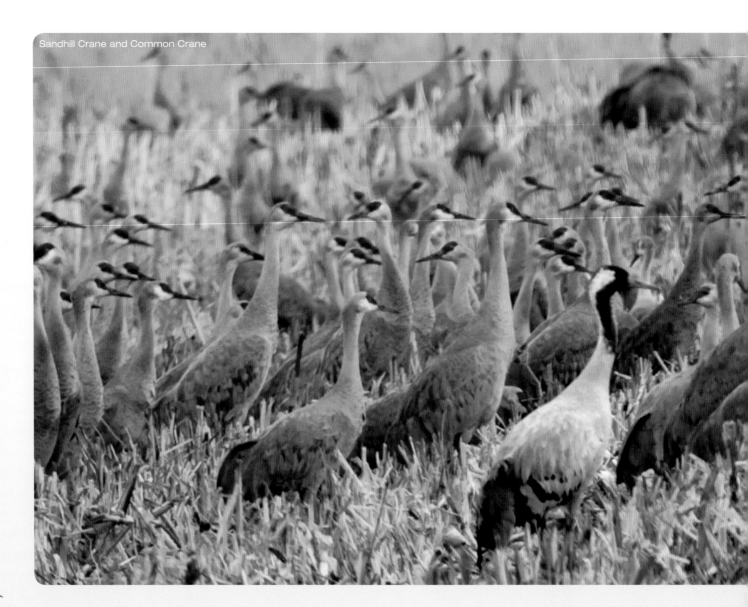
Sandhill Crane and Common Crane

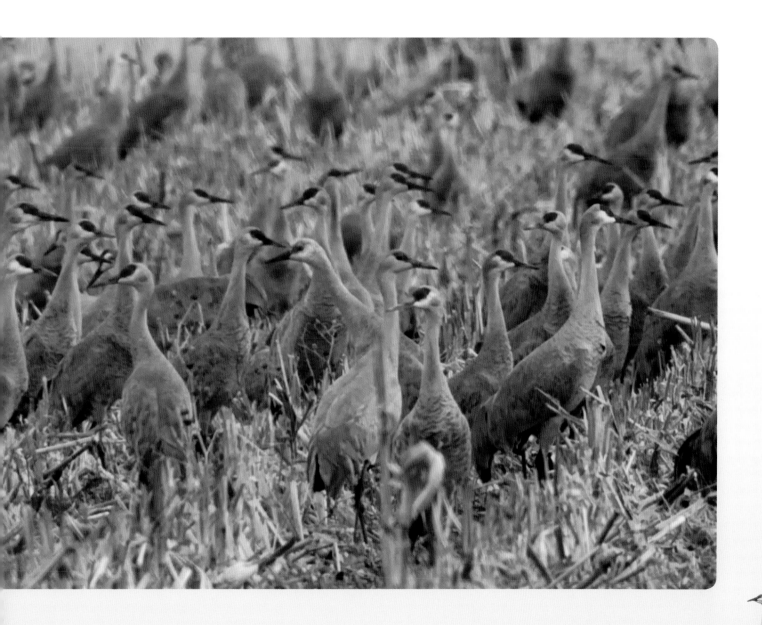

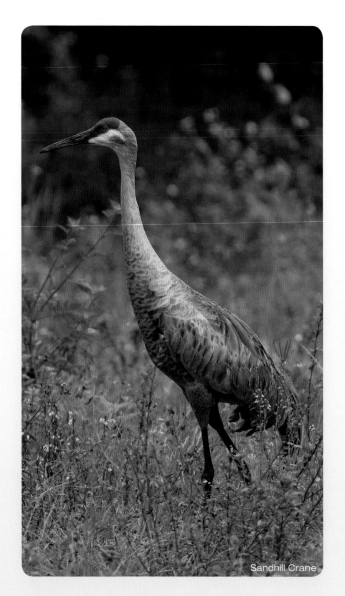

Sandhill Crane

Cranes are members of the Gruidae family and are not related to herons or egrets. Herons and egrets are wading birds in the Ardeidae family. The United States and Canada are home to the Sandhill Crane (*Grus canadensis*), Whooping Crane (*Grus americana*), and ten heron and egret species. Herons consist of the Great Blue Heron (*Ardea herodias*), Green Heron (*Butorides virescens*), Little Blue Heron (*Egretta caerulea*) and Tricolored Heron (*Egretta tricolor*), as well as the Black-crowned Night-Heron (*Nycticorax nycticorax*) and Yellow-crowned Night-Heron (*Nyctanassa violacea*). The Cattle Egret (*Bubulcus ibis*), Great Egret (*Ardea alba*), Reddish Egret (*Egretta rufescens*) and Snowy Egret (*Egretta thula*) comprise our egrets.

Very rarely, a European crane, called the Common Crane (*Grus grus*), has been sighted in the United States. One year, while leading a birding trip to Nebraska, I was very fortunate to spot and photograph this particular individual in a cornfield with a flock of migrating Sandhills! You can easily pick out the bird on the extraordinary photo on page 12.

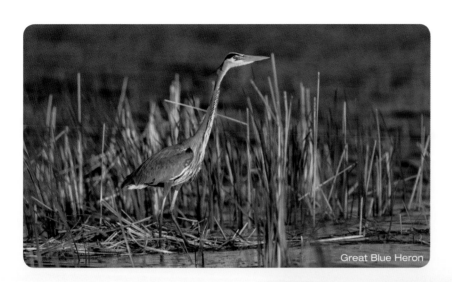

Great Blue Heron

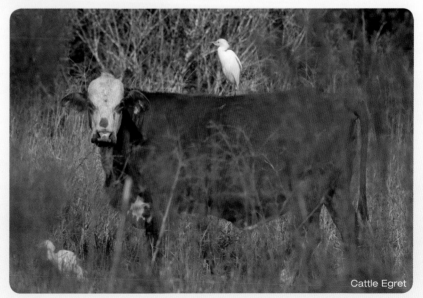

Cattle Egret

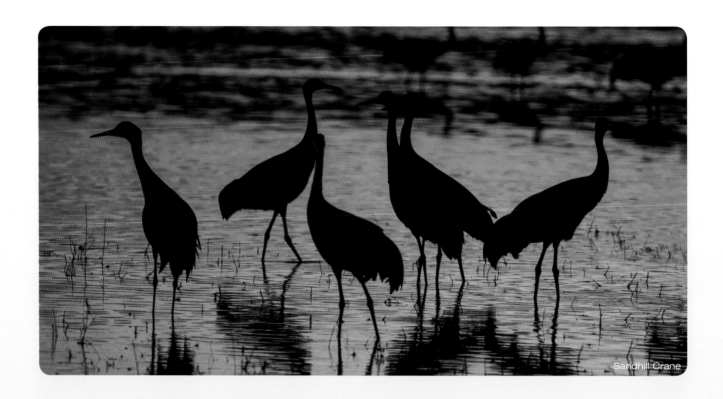
Sandhill Crane

MYSTERIES OF THE COMMON NAMES

The origins of a bird's common name are often shrouded in history, with the original meanings lost. "Crane" may have originated from the ancestral European root word, *gar* or perhaps *ker*. Both mean "to cry out" and describe the calls of cranes very well. The Greek *geranos* also appears to mean "crane." Later, the Anglo-Saxons called this kind of bird *cran*, which is more like the present name.

"Heron" apparently stems from earlier English and French words. The Middle English *heiroun* and *heyron* described a tall man with long legs, and the Old French *hairon* meant the same. Over time, the names changed and eventually became "heron," describing a bird with long legs. "Night-Heron" was assigned to herons that feed mainly at night.

"Egret" comes from the French *aigrette*—the name for the spray of head plumes on egrets during the mating season. "Cattle" Egret got its name from its habit of hunting around cow pies.

The name "Sandhill" refers to the Sandhill region of western Nebraska. This area is thought to be where Sandhill Cranes were first observed doing their courtship dance.

"Whooping" describes the call delivered by Whooping Cranes. They make an extremely loud whooping sound that can be heard up to a mile away.

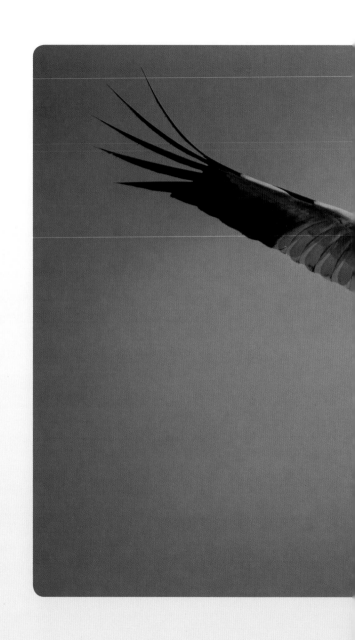

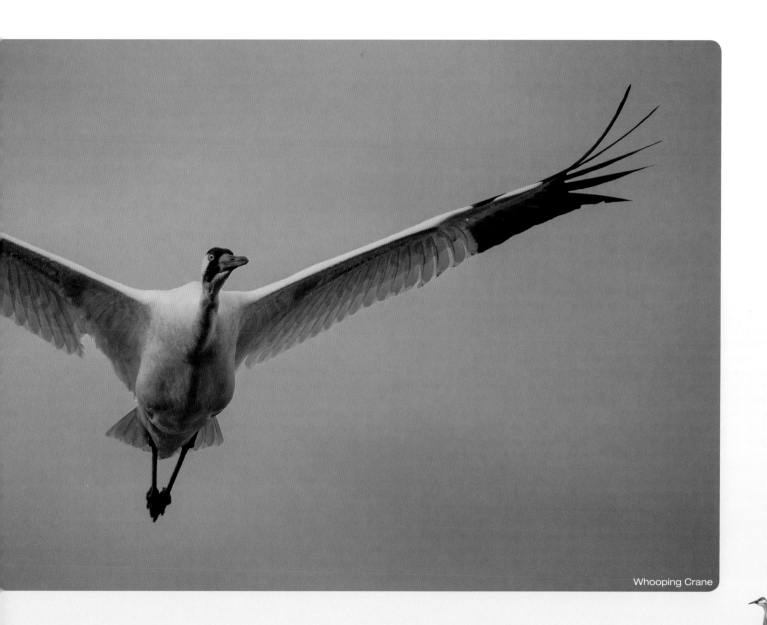

Whooping Crane

ROOTS OF THE SCIENTIFIC NAMES

The *Grus* genus name stems from Latin, and the genus includes all crane species around the world. The genus *Ardea* means "heron" in Latin and includes a number of New and Old World herons, as well as the Great Egret. The genus *Egretta* includes some species of egrets and also herons.

The species name for Sandhill Cranes, *canadensis*, refers to Canada, one of the places where Sandhills nest. The species name *americana* was chosen for Whooping Cranes because the birds occur only in the Americas.

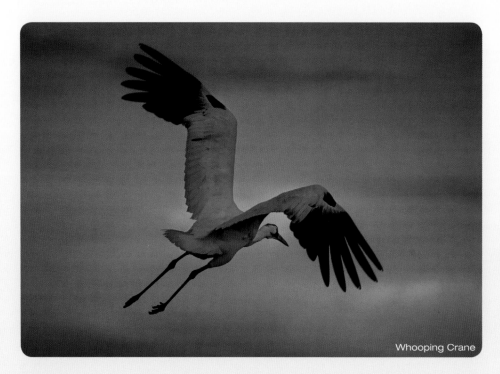

Whooping Crane

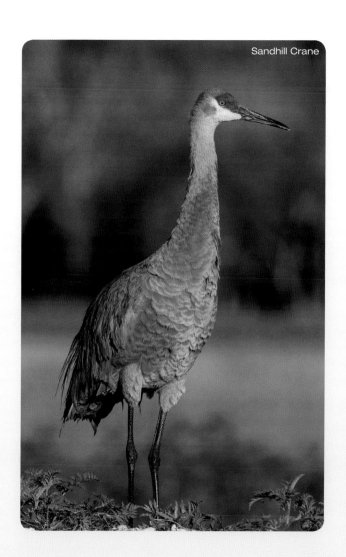
Sandhill Crane

SANDHILL CRANE SUBSPECIES

The Sandhill Crane (*Grus canadensis*) is the most common crane in the world and has only two major subspecies: Greater Sandhill Crane (*Grus canadensis tabida*) and Lesser Sandhill Crane (*Grus canadensis canadensis*). It is often hard to tell the difference between them in the field, but if they are standing near each other, the size difference is pronounced. The Greater is at least several inches taller and weighs a bit more than the Lesser. The beak is also about 40 percent longer, which is easy to see when a Greater and a Lesser stand side by side.

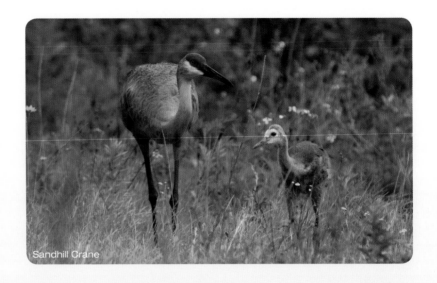
Sandhill Crane

The eastern population of Greater Sandhills breeds in the upper Midwest and Great Lakes regions, extending into Canada. This population once struggled due to overhunting and habitat loss; by the 1930–40s, there were few, if any, of these birds left. For example, Wisconsin had about 25 pairs, Michigan's population in the Lower Peninsula dropped to 17 pairs, Minnesota had a few scattered pairs, and places like Iowa, Illinois and Indiana had none. Populations now are estimated to be around 40,000–50,000! Most migrate to wintering grounds in Florida and Georgia, with a small percentage staying in Texas.

There are also smaller populations of Greater Sandhills in the Rockies and along the Pacific Coast. These birds winter in New Mexico, Arizona, California and Mexico.

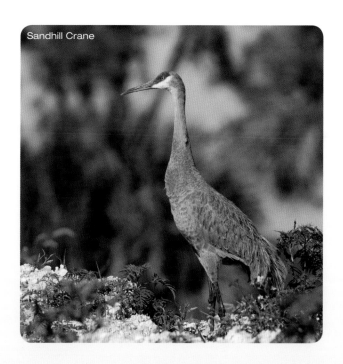
Sandhill Crane

Florida has its own subspecies of Greater Sandhill Crane (*Grus canadensis pratensis*). These birds are endangered, with stable to decreasing numbers. They have a longer breeding season due to the mild climate, and they don't experience the rigors of migration. Many live in the wetlands of suburban communities. Mississippi also has a separate population of non-migratory Greater Sandhill Cranes (*Grus canadensis pulla*), but this subspecies is not thriving well and is critically endangered.

The immense masses of cranes seen in the Platte River each spring are mostly Lesser Sandhills. They are the smallest subspecies but migrate the farthest. Most overwinter in Texas, New Mexico and Arizona, often mixing with Rocky Mountain Greater Sandhills.

In spring, the Lesser Sandhills leave their wintering grounds to head north and funnel down into the narrow 75-mile stretch of the Platte River. After spending a few weeks feeding and resting, they continue their long journey northward.

Gradually, they turn northwest toward western coastal Alaska and parts of northwest Canada, while others push on to northeastern Siberia. Just how many make this amazing trip is unknown, but Russian ornithologists estimate 25,000–50,000 individuals. These birds fly 4,000–6,000 miles and cross the Bering Sea, making a round-trip total of 8,000–12,000 miles of flight each year!

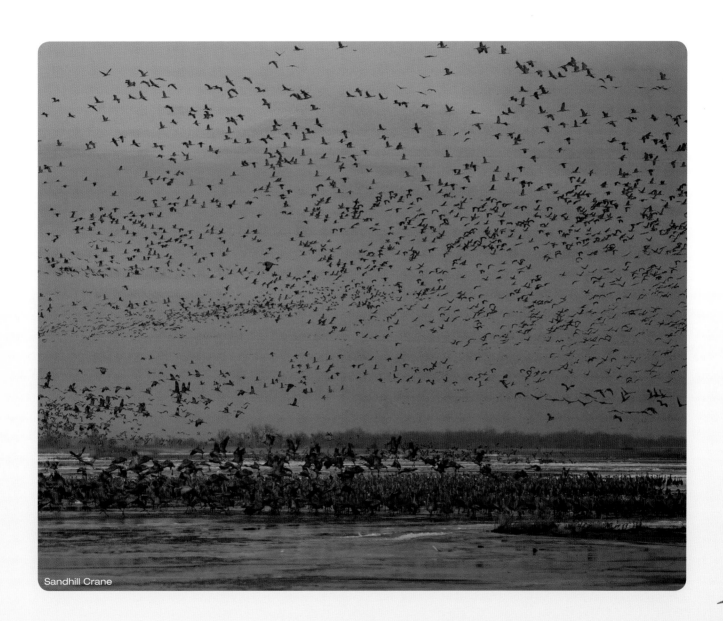

Sandhill Crane

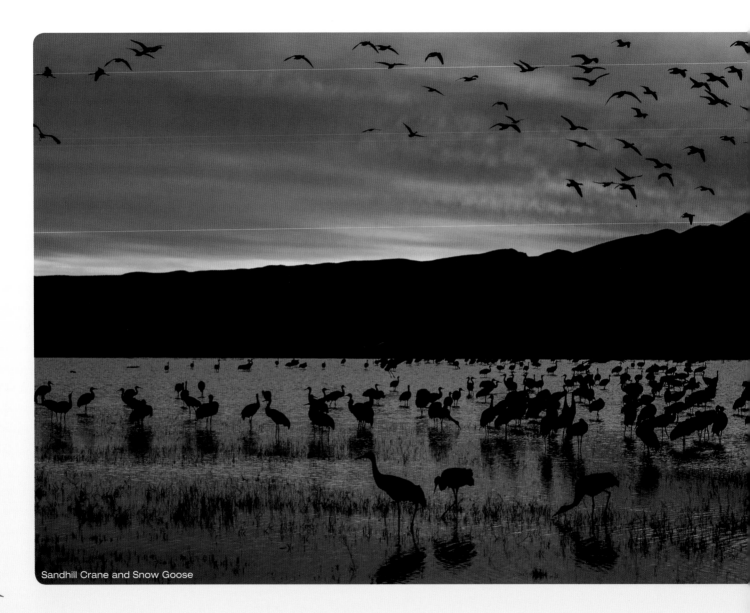

Sandhill Crane and Snow Goose

26

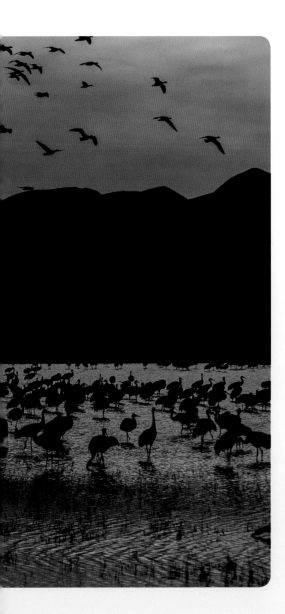

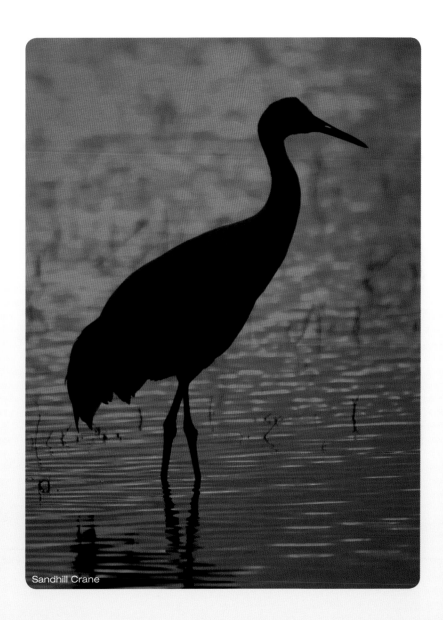

Sandhill Crane

CHANGING POPULATIONS

Generally, heron and egret populations follow the latitudes. The farther south the latitude, the more the populations occur. Because the birds rely heavily on shallow waters and fish to survive, they concentrate in warmer climates where food is abundant.

Herons and egrets have both suffered and prospered at the hands of man. They had extremely healthy populations in colonial times, but unregulated hunting caused a sharp decline and many became close to extinct. More recently, the populations have rebounded and are doing fairly well.

Sandhill Crane

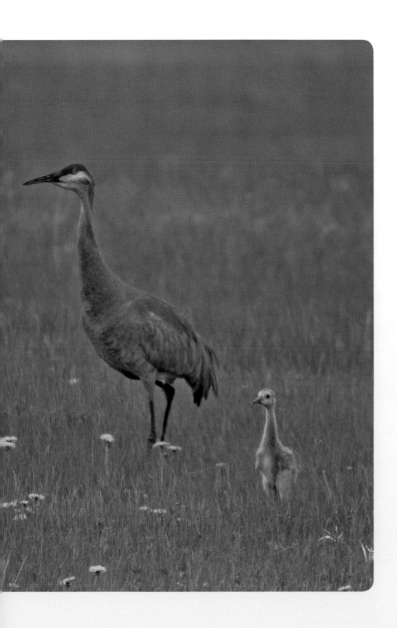

This population pattern is also true for cranes. Over the past 30–50 years, we've seen a huge increase of Sandhills. I've been leading birding trips to see cranes for about 30 years and have witnessed this firsthand. Years ago, if we saw a couple hundred cranes during fall migration, it was an amazing trip. On the same trips now, we routinely see 4,000–5,000 cranes! Today, they nest and raise young in many places.

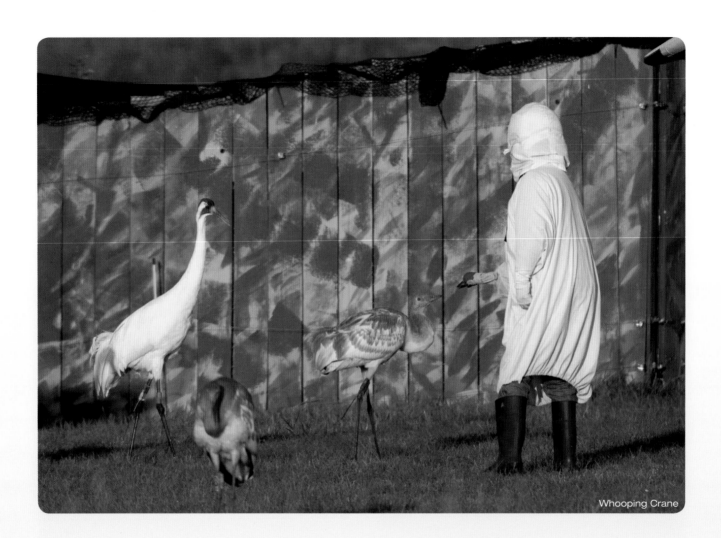
Whooping Crane

Whooping Cranes have perhaps suffered the most. Except for the California Condor, it can be argued that no other bird has come so close to extinction than the Whooper. In the early 1940s, the total number of Whooping Cranes was fewer than 20 individuals!

It wasn't until after World War II that restoration of the population began. We knew little about Whoopers back then, and it wasn't until 1954 that we discovered the only place where they nested—Wood Buffalo National Park in Canada. At that time, the population was still around 21 adult birds.

In the mid-1960s, a captive breeding program began taking one egg from each wild nesting pair. The eggs were hatched and the young birds were bred in captivity, producing offspring that established populations away from the wild flock. These separate populations helped ensure that if a natural disaster or disease outbreak occurred, the entire wild flock would not be lost.

A banding project using color-coded bands on the legs of juveniles started in 1977. With bands on the birds, we began documenting Whooper migration and many more behaviors. This program continued until 1988. By 2007, it was determined that 20 of the 132 banded birds were still alive and reproducing, yielding a wealth of information never before known.

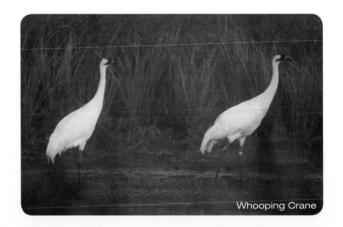
Whooping Crane

Today, we have a number of separate populations of Whooping Cranes. Some migrate, while others don't. There is also an experimental flock from Wisconsin that was trained by technicians in crane costumes (preventing human imprinting) to fly behind an ultralight aircraft and learn the migratory route to Florida. Now this small population migrates south and back on its own, with new members added each year. Perhaps in the future these birds will be successful enough to reproduce in the wild and establish a healthy migratory flock in their former range of Wisconsin and Minnesota.

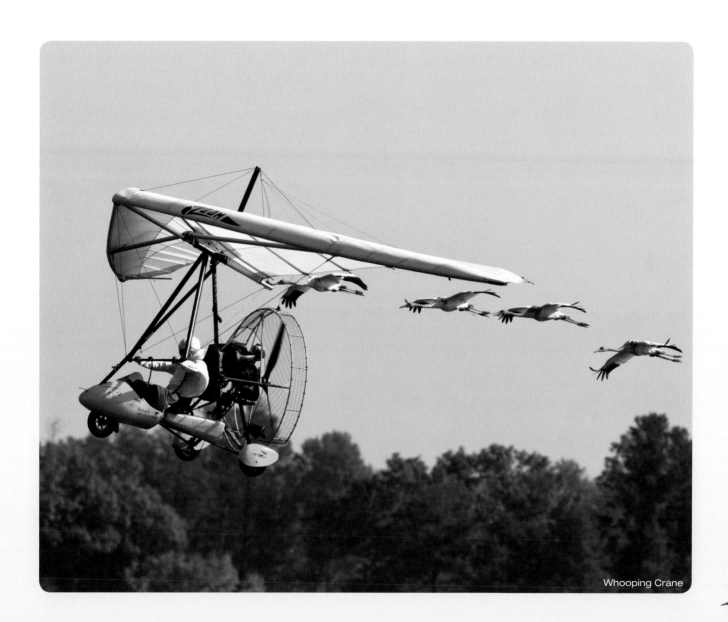

Whooping Crane

33

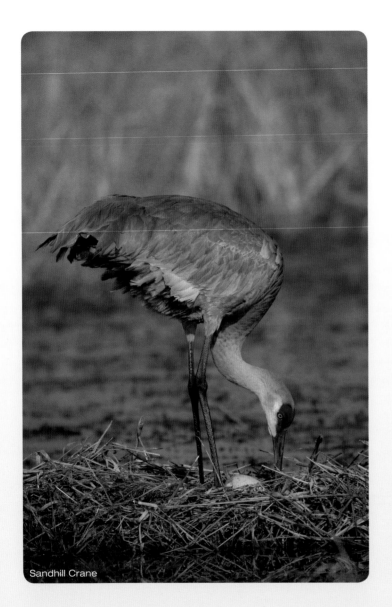
Sandhill Crane

The key to saving cranes, herons and egrets lies in proactive actions, starting with education. Since the 1970s, a nationwide environmental education program has been teaching children and adults about non-game species. Knowing the importance of conservation and preservation is vital for saving not just species, but also habitats.

Protecting habitats and creating or restoring more of them is crucial. Habitats providing adequate food and shelter are essential for life to thrive.

To change society's attitudes, legislation is needed. Laws protecting nongame species can prevent the extinction of these birds.

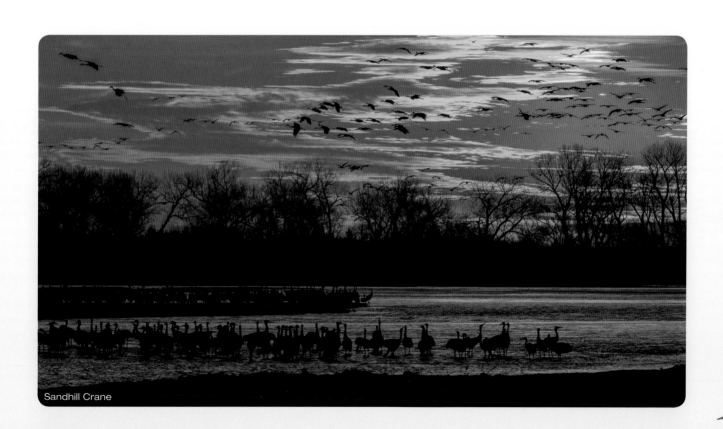

Sandhill Crane

35

DIFFERENTIATING THE SEXES

Cranes, herons and egrets are non-dimorphic birds. This means the males and females look the same or nearly identical.

In Sandhill and Whooping Cranes, you can see slight differences between the sexes if you look closely or if a pair is standing near each other. Males tend to be slightly larger and taller and often have a larger collection of tail feathers, called a bustle. The bustle gives the birds a more decorative and elaborate appearance during the breeding season.

In herons and egrets, there is no pronounced size difference between the males and females, so differentiating the sexes is nearly impossible.

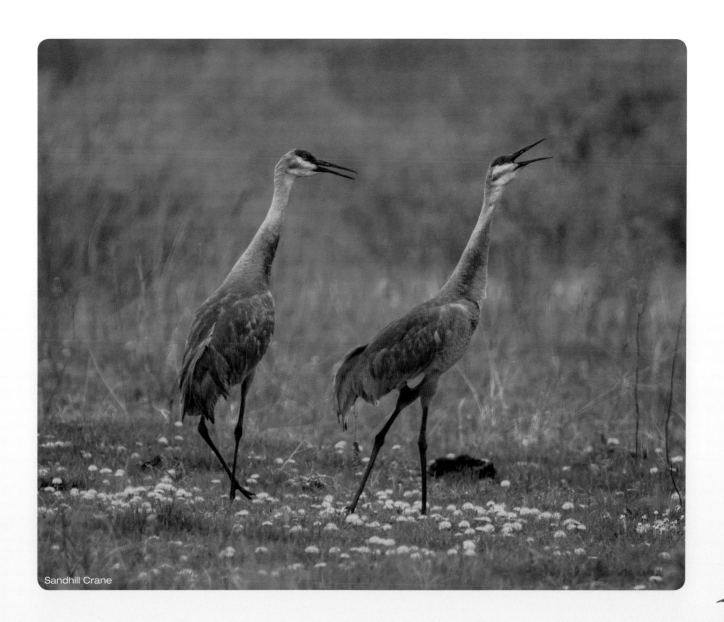

Sandhill Crane

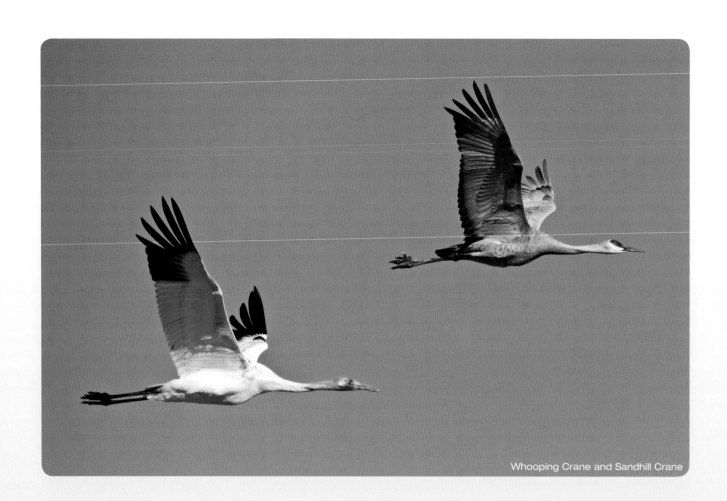

Whooping Crane and Sandhill Crane

SIZE TALL, IF YOU PLEASE

Cranes are extraordinarily tall birds. In North America, the Whooping Crane is the tallest bird, with a height of about 4½ feet. Greater Sandhill Cranes are around 4 feet tall. Lesser Sandhills are about 4 inches shorter. Whooping Cranes are more powerful and noticeably taller than Sandhills and dominate them when they interact. I've watched Whoopers aggressively chase Sandhills away from good food sources with ease.

The largest of the herons is the Great Blue Heron. This is a nearly 4-foot-tall bird with mostly gray plumage, contradicting its name. These elegant birds have exceptionally long legs, allowing them to wade into deeper water where they hunt for fish, frogs and aquatic insects. Tricolored and Little Blue Herons are next on the size chart. The Tricolored stands at just over 2 feet, while the Little Blue is 2 feet tall, with their legs accounting for much of the height.

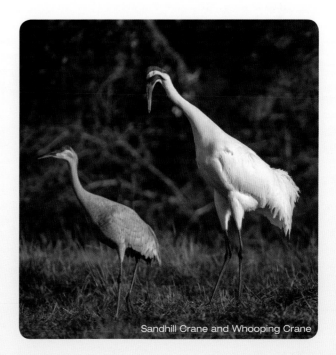

Sandhill Crane and Whooping Crane

Black-crowned Night-Herons, Yellow-crowned Night-Herons and Green Herons round out the heron group by size. Generally the shortest herons, they have shorter legs and tend to have squat bodies and shorter bills. Black-crowns are just over 2 feet, Yellow-crowns stand at 2 feet, and Green Herons are the smallest, ranging 16–22 inches. They wade in shallow or still water, hunting mainly for tiny fish. Many times they balance on small branches or twigs hanging just above the water to hunt.

Egrets are a similar group of birds that are perhaps slightly more diverse. Great Egrets are the largest and the stateliest, standing just over 3 feet tall. Reddish Egrets are much smaller, around 30 inches. Snowy Egrets come in at 2 feet tall, while Cattle Egrets measure about 20 inches. Their long legs are essential because, like herons, egrets also make a living stalking and stabbing fish. Many of these species will also hunt and catch fish while flying over water.

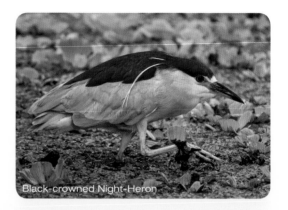
Black-crowned Night-Heron

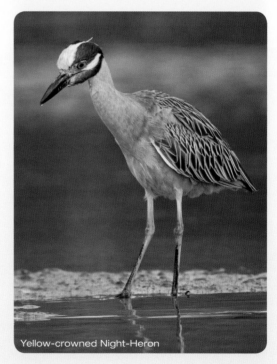
Yellow-crowned Night-Heron

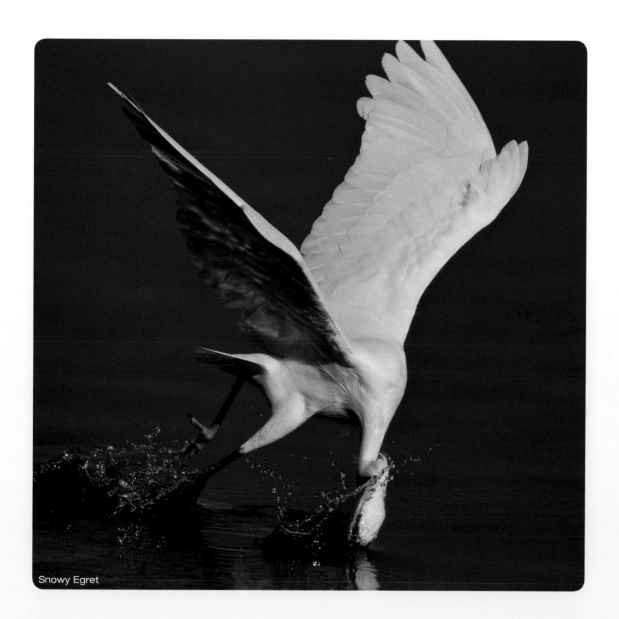

Snowy Egret

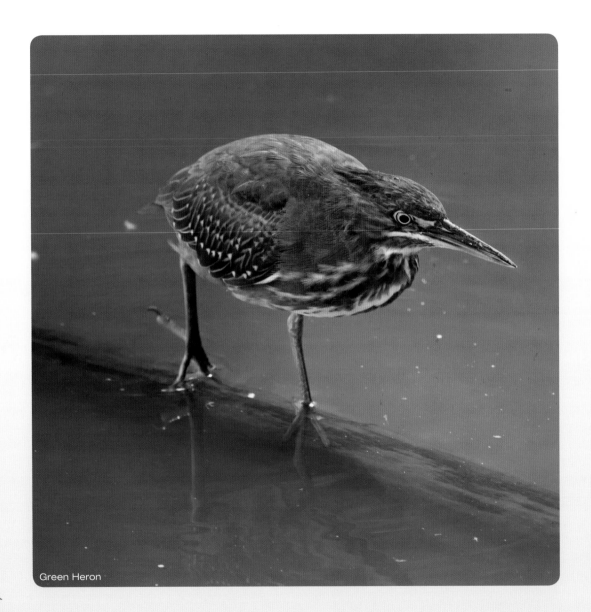

Green Heron

Great Blue Heron

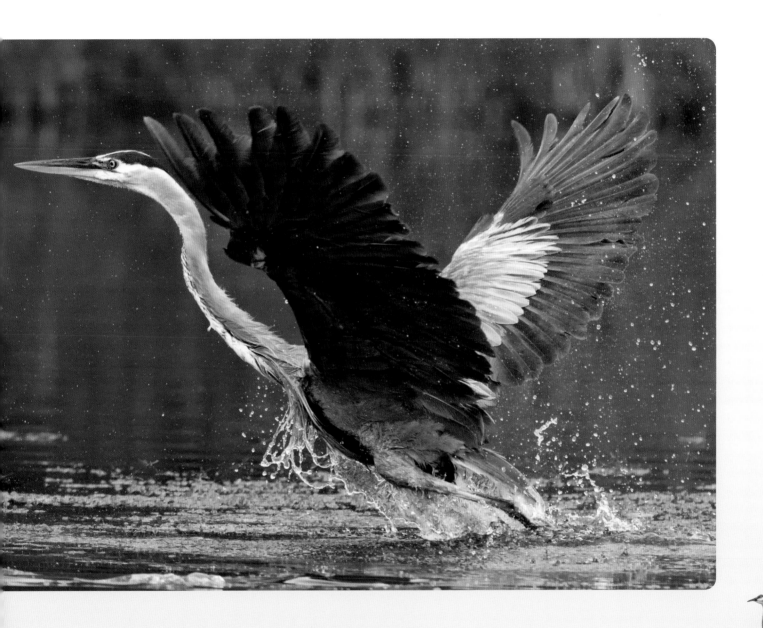

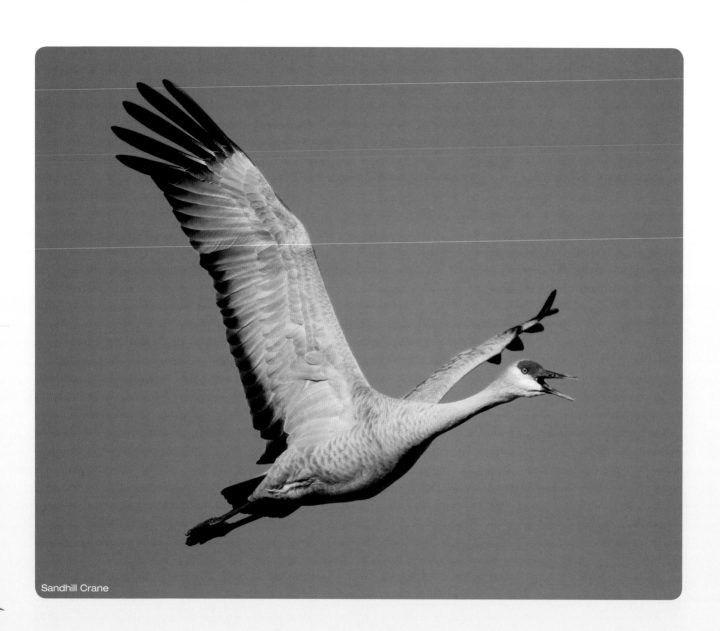

Sandhill Crane

44

Cranes, herons and egrets all have fairly similar life spans. Like many birds, their longevity is related to their size. There are some exceptions, but, in general, the larger the bird, the longer it lives.

As some of the largest birds in North America, cranes tend to live longer than herons and egrets. If they survive their first few years, they live about 20–30 years on average. The oldest known Sandhill Crane lived 36 years and 7 months! It was originally banded in Wyoming in 1973 and was recovered in New Mexico in 2010.

Herons are smaller and live around 15–20 years. The oldest known Great Blue Heron was reported to be 23 years old. Egrets, which are smaller still, live about 10–15 years.

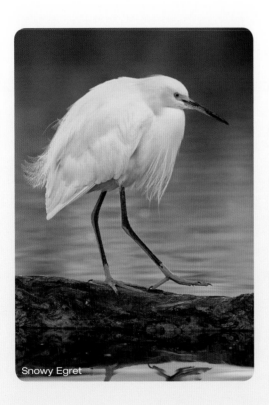
Snowy Egret

FANCIFUL FEATHERS

When it comes to the natural world, there's no body covering quite like the amazing feather! Feathers do so much more than cover birds. Fluffing and compressing feathers helps birds regulate their body temperature, keeping them warm or helping them stay cool. Feathers also help waterproof birds and protect them from harmful UV light from the sun.

Feathers are simple, lightweight and help give birds the ability to fly. This amazing feat sets birds apart from all other warm-blooded creatures except bats.

In addition, feathers advertise a bird's overall health and sexual readiness. Fancy feathers are a visual way to show that an individual is healthy and could produce healthy offspring.

In herons and egrets, adults grow elaborate, showy plumes that announce they are ready to breed. Breeding Great Blue Herons grow a set of long, narrow black plumes at the back of the head and fancy feathers at the base of the neck. Great Egrets flaunt an eye-catching set of long plumes to advertise their nesting time. Reddish and Snowy Egrets also display fancy feathers to attract a mate.

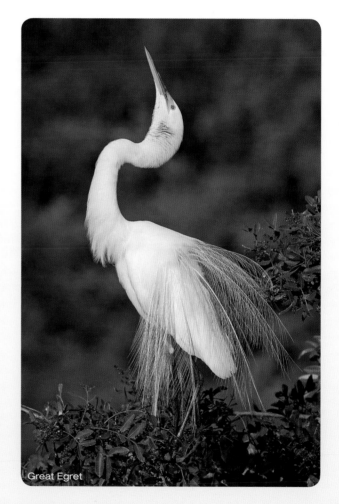

Great Egret

Sandhill and Whooping Cranes produce feather bustles—long, specialized tail feathers that look very impressive when fluffed up.

Sandhill Cranes take dressing up a step further. During winter, the birds are gray. In spring, during migration to the breeding grounds and especially on arrival, they spread mineral-stained water through their feathers, which slowly stains them to a rusty brown. No one knows why Sandhills do this. They may be trying to blend into the habitat, rid themselves of tiny insects, or it could be just a nervous habit.

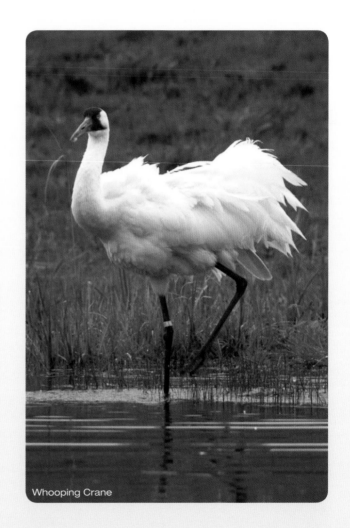

Whooping Crane

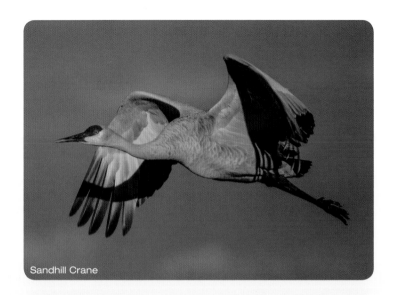
Sandhill Crane

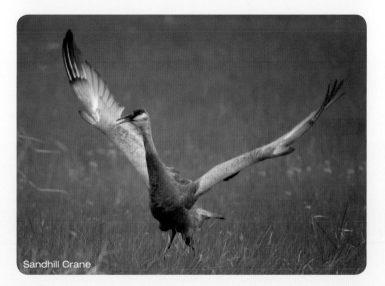
Sandhill Crane

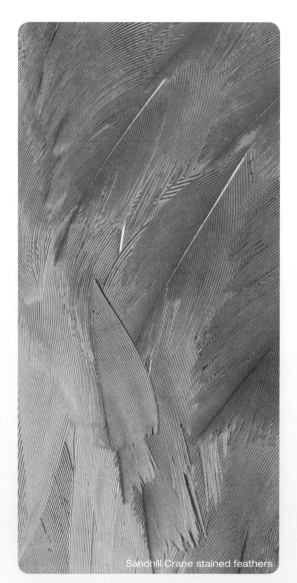
Sandhill Crane stained feathers

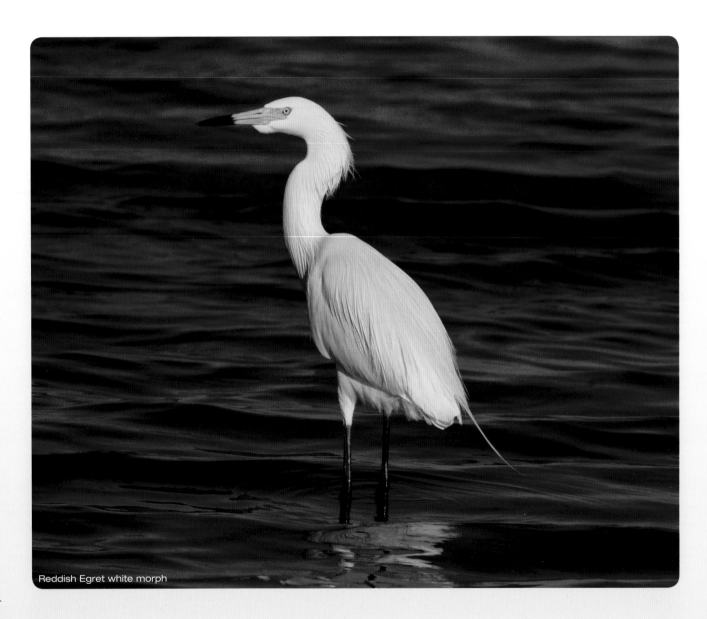

Reddish Egret white morph

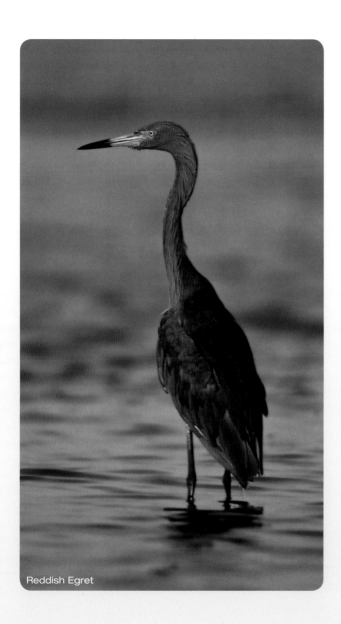
Reddish Egret

RARE WHITE MORPHS

Reddish Egrets and Great Blue Herons occasionally produce a white morph. Normally, the Reddish Egret has a handsome reddish head and neck and a dark body, and the Great Blue Heron has bluish gray feathers. The white morph of both species has all-white feathers. White morphs in these species are extremely rare and occur only in a few places in North America. It is important to note these birds are not albino.

YOUTHFUL PLUMAGES

When young egrets and Great Blue, Little Blue and Tricolored Herons leave the nest, their plumage looks much like that of their parents, even though it might be several years before they are ready to breed. Not so with Green Herons and Black- and Yellow-crowned Night-Herons. These juveniles have more marks or streaks than their parents, and they lack the sleek adult appearance. Why this occurs is not understood by scientists.

Juvenile Little Blue Herons are highly unusual. From the time they hatch until the following spring, they resemble Snowy Egrets! They have white feathers, yellowish green legs and dark-tipped bills. As they approach one year of age, they start to get mottled with gray. By two years of age, they complete the transformation to adult plumage, which is dark grayish blue. This is the way they will stay for the rest of their lives.

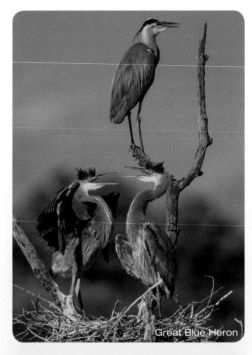

Great Blue Heron

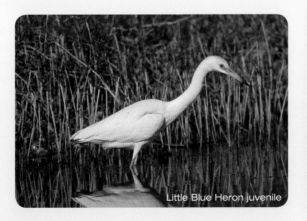

Little Blue Heron juvenile

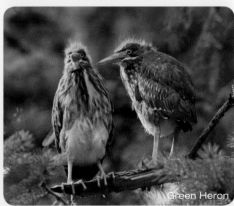

Green Heron

Young Sandhills and Whooping Cranes start out in a coat of down feathers that are tan to rusty brown. Unlike herons and egrets, which leave the nest nearly full-grown, crane babies are out of the nest within one day of hatching. Compared to their parents, they are tiny and have a long way to grow before approaching the size of the adults. It is usually not until later in summer that the babies look more like the adults.

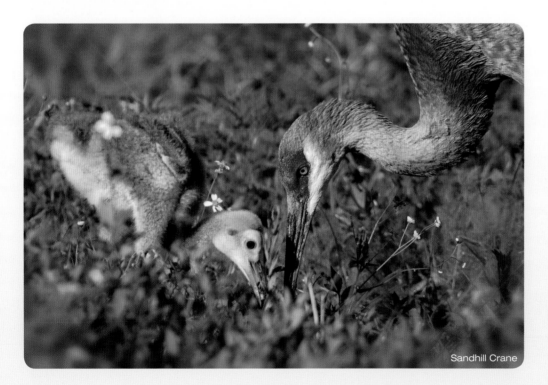

Sandhill Crane

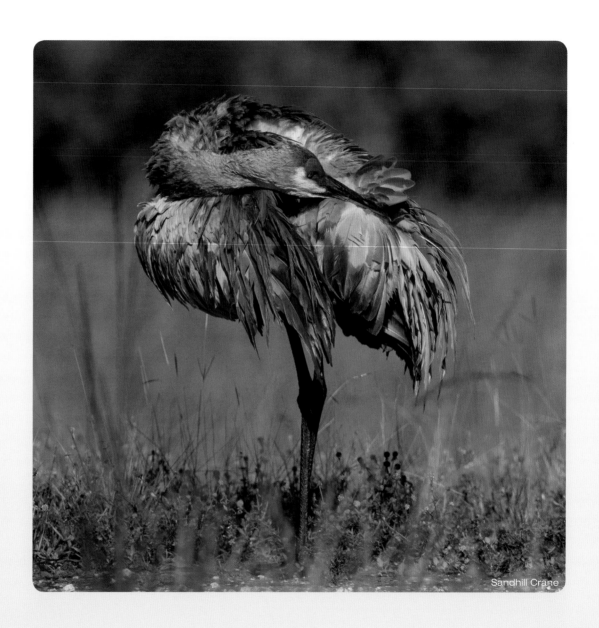

Sandhill Crane

FEATHER GROOMING

Birds rely on their feathers for nearly every aspect of life, and keeping them clean and tidy is critical. Feather replacement in cranes, herons and egrets occurs only at specific times of the year, so if some feathers were to wear out prematurely, new ones would not grow in until later. Early feather loss, especially flight feathers, creates a serious disadvantage for these birds and can be the difference between life and death.

Cleaning, straightening and smoothing feathers with the bill, called preening, helps extend feather life. Cranes, herons and egrets spend much of their time at this activity, delicately pulling and rearranging their tiny down feathers to their largest flight feathers, keeping all in fine condition.

POWDER DOWN

Powder down is a highly specialized type of feather that occurs in just a few groups of birds. Herons and egrets have powder down on their chests, differentiating them from storks, ibis, spoonbills and other similar-looking birds.

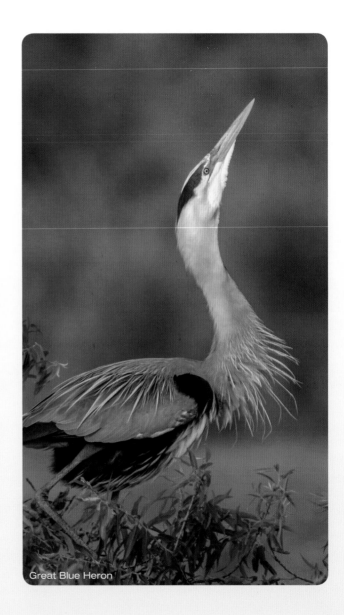

Great Blue Heron

Unlike other feathers, powder down grows continually and is not molted or replaced seasonally. The tips of powder down feathers break apart or disintegrate into fine particles that resemble white dust, often called feather dust.

Herons and egrets grab the tips of their powder down feathers with their bills, collect the dust particles and move them onto their other feathers. The powder dust acts like a cleaning agent and lubricant. The birds often spread it around with a special fringed claw on their middle toe. Having powder down feathers often reduces their need to bathe in water as frequently as other birds, and also augments buoyancy while swimming.

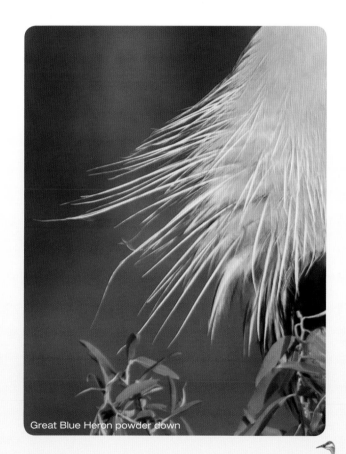
Great Blue Heron powder down

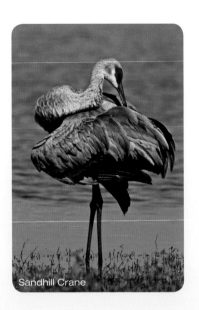
Sandhill Crane

WET AND DRY WASHING

Keeping feathers in tip-top shape is a matter of life or death for birds. So even though herons and egrets spend a lot of time in water, they still take time to bathe. Washing with water helps remove dirt, fish scales, insects and any other foreign items lodged in the feathers. After this, they preen, rearranging and primping their feathers. These preening sessions can last 1–20 minutes.

Cranes don't spend as much time in water as herons and egrets, but they keep themselves just as clean. They bathe, but perhaps dry wash a bit more and are just as diligent at preening as herons and egrets.

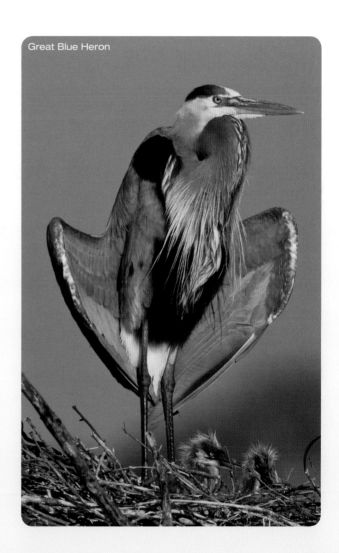

Great Blue Heron

SUNNING TIME

Nearly all cranes, herons and egrets engage in intentional sunning. They normally get plenty of sunshine during the day, but occasionally they will face the sun, droop their wings and hold them slightly spread apart. This position allows sunlight to heat areas of the body that are not usually exposed. Warm sunlight not only feels good, but it keeps feathers supple and may help rid the skin of insect pests.

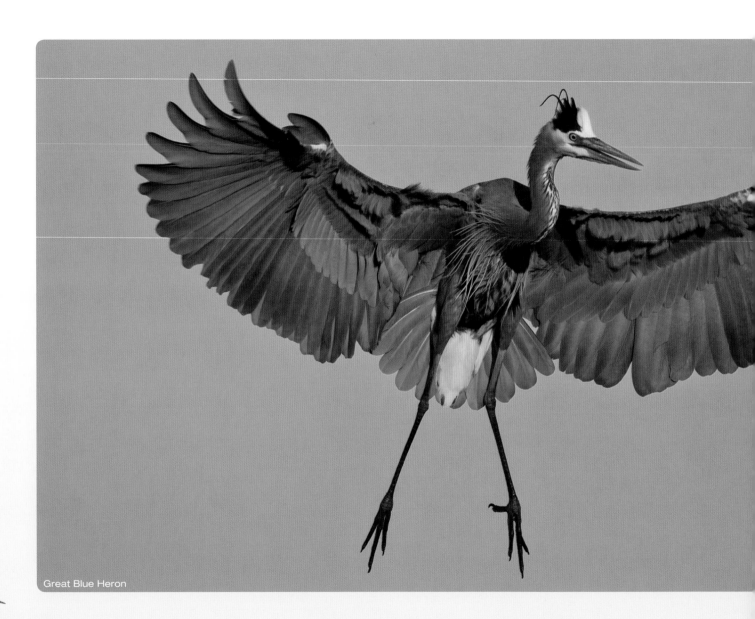

Great Blue Heron

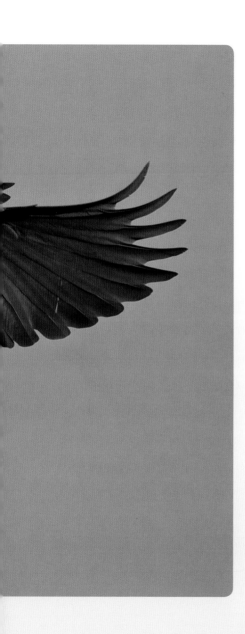

WING TIP TO WING TIP

Almost all of the cranes, herons and egrets are highly migratory. They need to move from their breeding grounds in spring and summer to places where the ponds, lakes and streams don't freeze during winter and where there is food. This means most have to fly hundreds, if not many thousands, of miles.

These birds have large wings to carry them on the wind to their destinations. Sandhill Cranes have wingspans in the range of 5½–7 feet. At 7¼ feet, the wingspans of Whooping Cranes are huge.

Great Blue Herons have eye-catching 6-foot wingspans, and other herons have equally impressive measurements. Even the egrets have considerable wingspans. For example, the span from wing tip to wing tip in Great Egrets is 4½ feet.

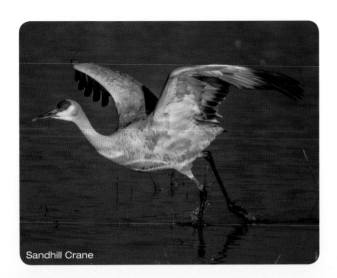
Sandhill Crane

TAKEOFF AND STAYING ALOFT

Sandhills have long, broad wings that lighten their wing load. At takeoff, they face into the wind and run a number of steps while flapping. They use typical wing beats and sometimes fly with a characteristic "wing flick." When lifting their wings, they flick up their wing tips in an exaggerated movement and keep repeating it, making the wing flicks very obvious.

Herons and egrets share the same type of long, broad wings. Facing into the wind at takeoff helps control their flight direction, makes them aerodynamically efficient and promotes lift. This saves energy and gets them aloft faster.

Great Blue Herons fly with short, choppy wing beats. They arch their wings, never fully extending them to a flattened position. Due to their heavy body weight, they must flap constantly and can glide only rarely. Specialized neck vertebrae enable them to curl their necks in a distinctive "S" shape during flight. Egrets and smaller herons fly with more normal wing beats and extended necks.

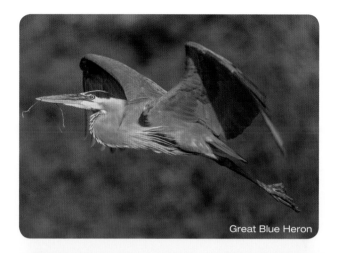

Great Blue Heron

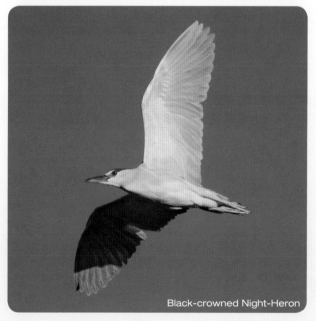

Black-crowned Night-Heron

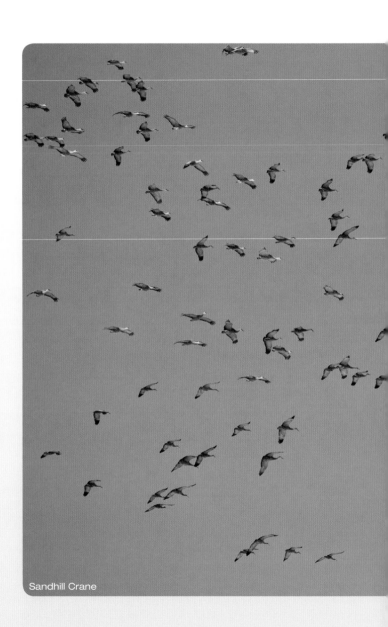

Sandhill Crane

RIDING THE THERMALS

Sandhills are famous for soaring and circling on rising columns of warm air, called thermals. The larger the thermal, the wider the circling. Flocks of migrating cranes soar to the top of thermals, gliding in the direction of their destination. When a thermal rises higher, it cools and loses momentum. Now the birds break away to hitch a ride on a new rising column, repeating this over and over throughout the day. Large groups use the same thermal, often creating a traffic jam in the sky.

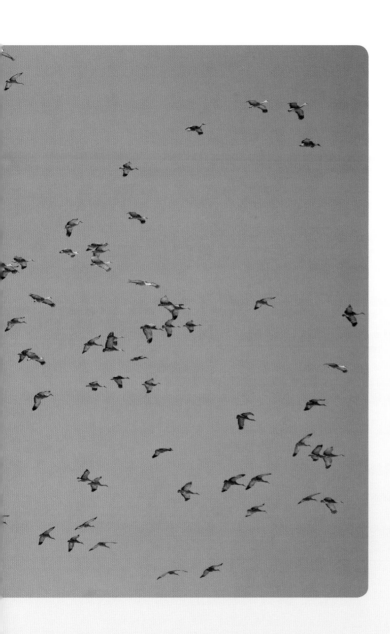

Thermal flight helps birds conserve energy and can help them migrate faster. Studies show that cranes can save more than 20 percent of their energy when soaring in thermals compared to normal flight.

After migration, Sandhills and Whoopers fly in thermals for exercise. They do this daily, flapping hard to catch a thermal to ride to the top, and then peeling off to find another.

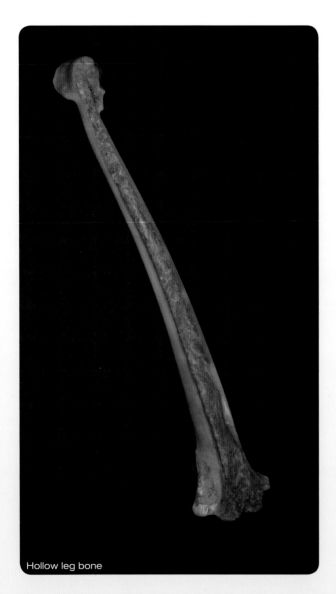

Hollow leg bone

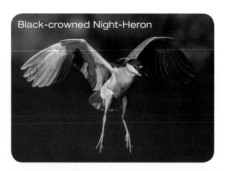

Black-crowned Night-Heron

HOLLOW BONES FOR FLIGHT

When compared to mammals, birds have fewer bones, but more are fused together and occur in different shapes. Also, a specialized bone known as the furcula, commonly called the wishbone, allows a bird's chest wall to expand and contract during flight. All of these modified bones help facilitate the ability to fly.

Cranes, herons, egrets and most other birds have lightweight, hollow bones, called pneumatic bones, with air filling the space instead of bone marrow. Loons, which spend much of their time underwater, have heavier, semi-pneumatic bones. Flightless birds, such as penguins, have solid bones. Moreover, the pneumatic bones of cranes, herons and egrets are also strong and flexible and provide excellent support for the larger bodies of these birds.

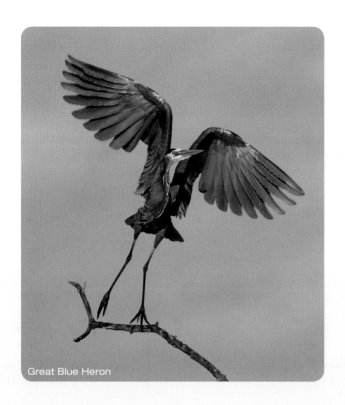
Great Blue Heron

MUSCLE POWER

Birds are able to fly in large part because of their feathers and lightweight bones, but there's more that makes it possible. A bird's pectoral muscles, which are used for flying, are larger than those in similar-sized mammals. In some bird species, these muscles make up a large percentage of the overall body mass. In addition, specialized wing muscles attach to a modified sternum or breastbone, called a keel, to power the wings.

Supplying blood to the muscles is a large, strong heart. Like the pectoral muscles, a bird's heart is larger and more powerful than the heart of a mammal of comparative size. Finally, the overall shape of the bird and the wing position on its body also lend to successful flight.

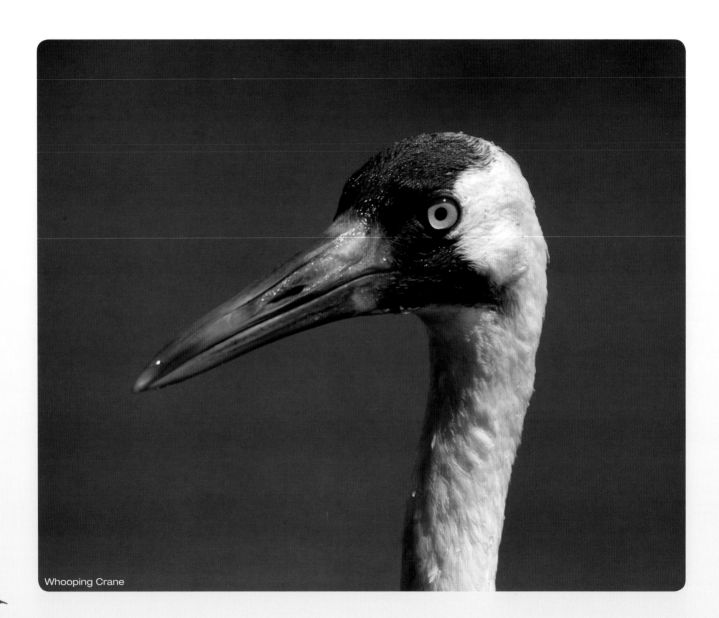

Whooping Crane

68

LONG, POINTED BILLS

The bill, also called the beak, is one of many unique features of birds. Bills are made of keratin—a lightweight, but very strong, material. While some bills have fine serrations or a large hook, others are sharply pointed. Cranes, herons and egrets have exceptionally long bills with sharp points.

Sizes and colors may vary, but all bills are similar in structure and function. Cranes, herons and egrets use their straight, dagger-like bills to cut through water and stab fish. The cranes also pierce mice, snakes, frogs, toads, worms and other prey items.

Birds use their bills for more than just preening and feeding. Cranes, herons and egrets carry sticks in their bills to build nests, manipulating branches of various sizes and also managing finer plant materials during the construction process. In addition, the bill is used for defense or, in some cases, to act out aggressively.

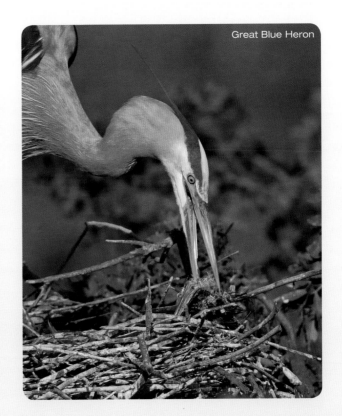

Great Blue Heron

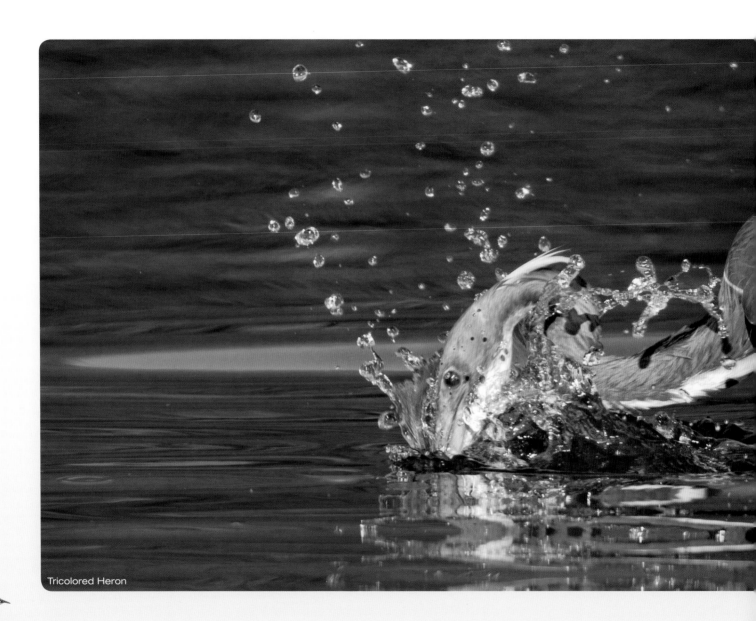
Tricolored Heron

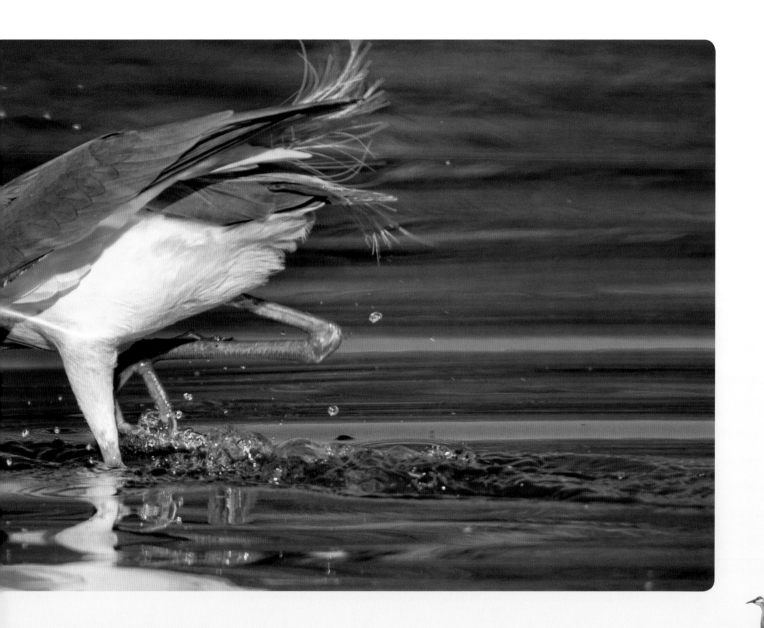

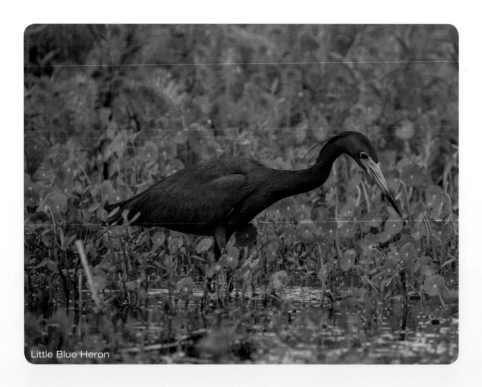

Little Blue Heron

WEAK SENSE OF SMELL

All of these birds have enlarged olfactory centers in their brains, but despite this, they have a weak sense of smell, and they don't use their nostrils to find food. Cranes eat a smorgasbord of items, from fish, seeds and grains to insects, amphibians and small mammals. Herons and egrets dine mainly on fish. To locate these kinds of underwater provisions, the birds use their eyes. The sense of smell plays no part.

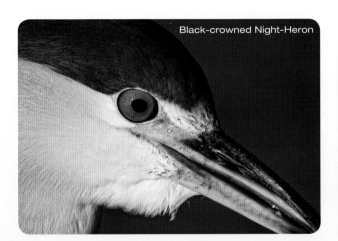
Black-crowned Night-Heron

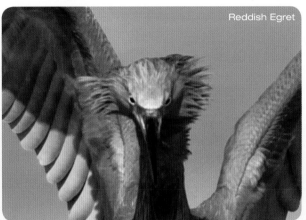
Reddish Egret

EYES FOR HUNTING

Excellent sight and eye placement are vital for these birds to find food. Eye placement on the sides of the head allows for better peripheral vision but makes for poor binocular sight. However, with eyes slightly forward on the head, the vision from each eye overlaps, providing decent sight in front and fairly good depth perception. Thus, the birds can capture tiny fish or pick up corn kernels or other morsels directly ahead of the bill.

Herons and egrets can hunt for food day and night, due, in part, to increased rods in the back of their eyes—which greatly improves vision during low-light conditions. This helps when hunting late in the day or just before daybreak. It may also help them see through murky water to the small fish lurking below.

SLENDER, SCALY LEGS

The long, slender legs of cranes, herons and egrets are highly specialized. What appears to be their knee bending backward is actually their ankle! The foot extends from the toes up to the ankle. The location of the knee is actually above the ankle, hidden in the feathers.

Some people mistakenly believe that the legs and feet of birds are covered with dead skin. But if you have ever held a bird, you know that its legs and feet are warm. This is because blood is circulating through the legs and feet, providing oxygen and other nutrients to living tissue, which covers the bones. Scales over the live tissue hark back to the reptilian ancestors of birds and are the perfect covering for legs and feet. Scales are strong, yet flexible, waterproof and easy to keep clean.

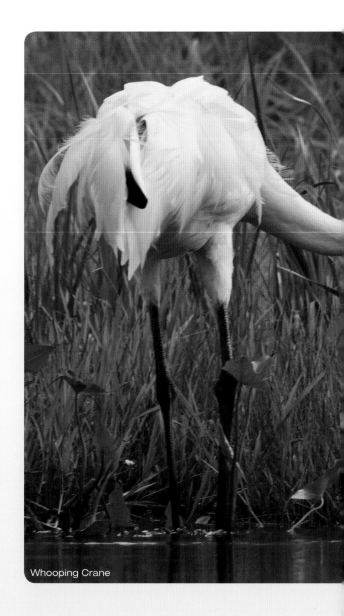

Whooping Crane

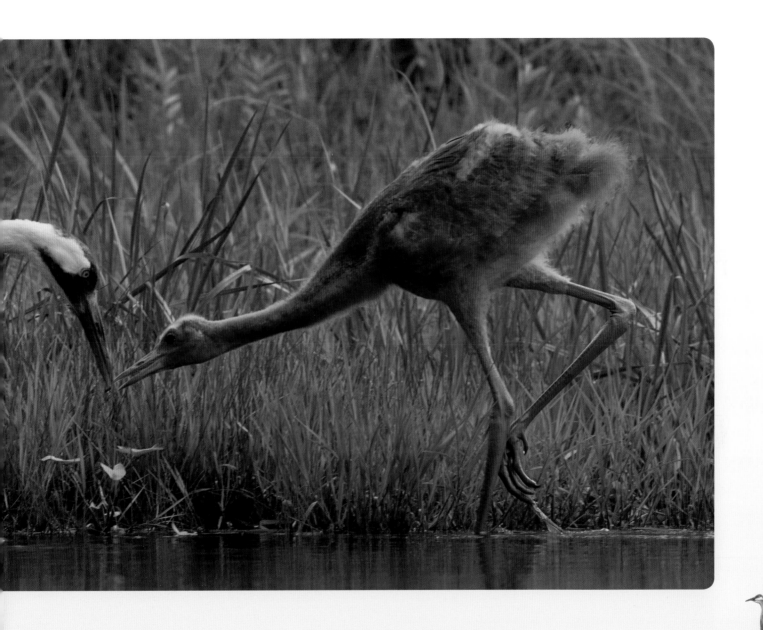

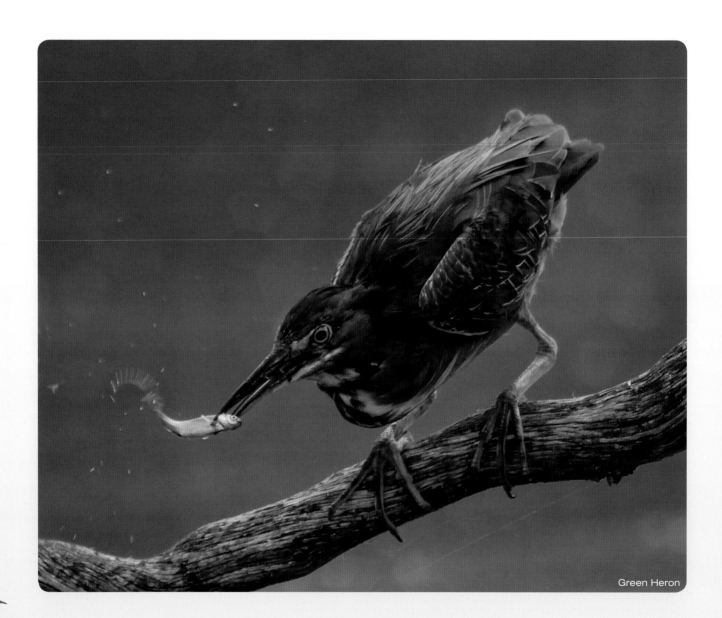

Green Heron

EXTREMELY STRONG TOES

Unlike mammals, which walk around flat-footed, birds walk on their toes at all times. The toes of cranes, herons and egrets are extremely strong, long and narrow, and act like a platform. As they walk, the toes fold up with each step, enabling the birds to draw the foot through the water with little resistance. Before putting the foot down, the toes spread out, allowing the foot to set securely on the bottom of ponds, lakes and rivers. Spread toes completely support the large body that towers above, and the toe muscles constantly make miniscule adjustments to help a bird maintain its balance.

Sandhill Crane track

Long, sticklike legs and extremely strong toes play a major role in the success of these birds. Most nest in trees on thin branches. Their trim legs and strong toes allow them to easily land and balance on a wide variety of branches, both thick and thin. This ability helps while hunting for food or landing at nest sites.

Herons and egrets use their legs and toes to wade in shallow water just deep enough to feed on fish. While cranes don't wade to fish as much as herons and egrets, they use their legs and toes in much the same way on land and in deeper water. They navigate the tall vegetation in fields and wetlands and venture into rivers and ponds to nest or to roost at night.

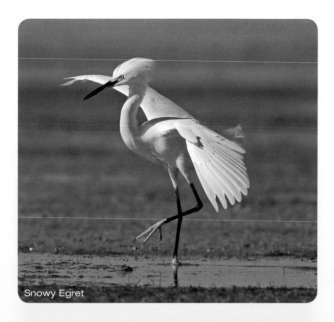

Snowy Egret

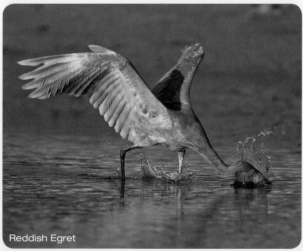

Reddish Egret

DESIGNED TO FISH

It is really a combination of attributes that make herons and egrets great fishers. Their long legs are the most important. Wading stealthily into shallow water where most small fish swim is essential. Their slow, methodical movement allows them to move through the water but not disturb the fish.

Their outstanding eyesight is next. Many of these birds have a tiny oil droplet in every rod and cone in the back of each eye that filters sunlight, much like a polarized filter. This reduces glare on the water's surface and allows the birds to see deeply into the water. Once they sneak up on a fish and eye it clearly, their long, pointy bill does a great job of slicing through the water and piercing the meal.

Last, the modified vertebrae of herons give them the ability to coil their necks in an "S" shape. Like snakes, they can also uncoil their necks at lightning speed, helping them to successfully spear their prey.

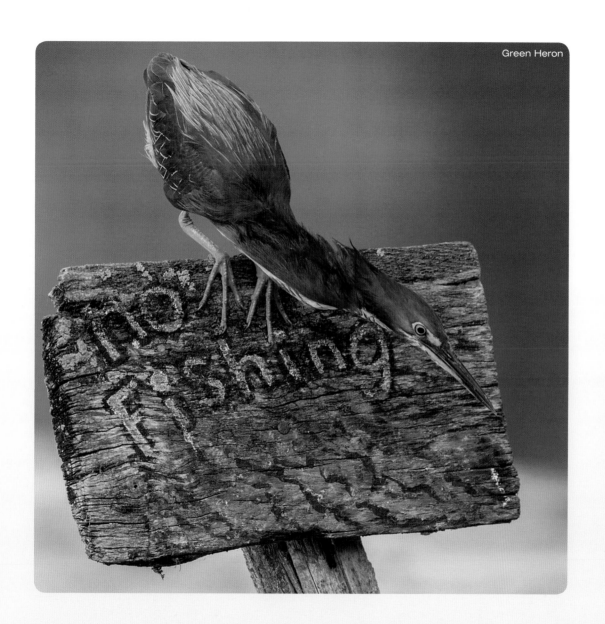

Green Heron

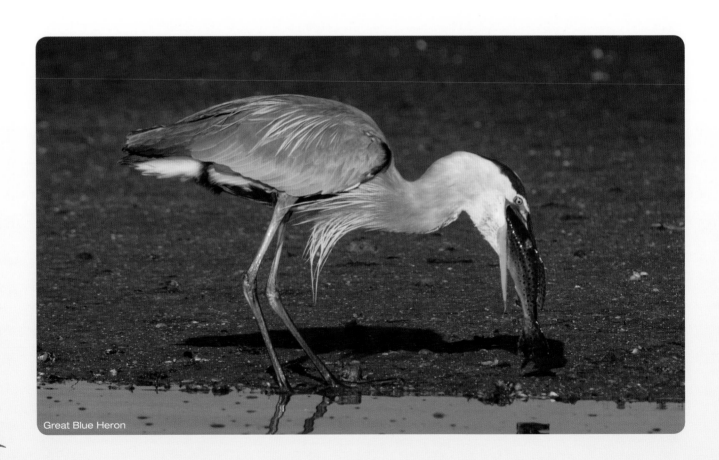

Great Blue Heron

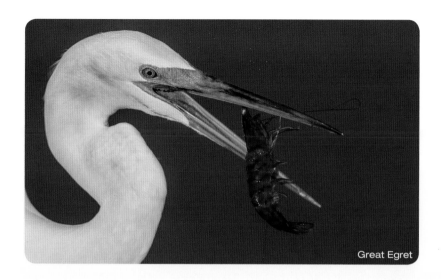
Great Egret

MENU SPECIALS

Cranes don't spend much time fishing. They eat a wider variety of food than herons and egrets, such as seeds, grains and fruit, which they find in prairies and agricultural fields. Cranes are efficient at catching mice, voles and other mammals as large as chipmunks, as well as frogs and snakes. They will also take other smaller prey, such as insects and worms.

Great Blue Herons stalk shallow ponds, lakes, streams and rivers mainly for fish, but they also eat frogs, salamanders, turtles, snakes, small rodents, small birds and chicks. They will eat just about anything that they can capture and that fits down their throat. They can catch and swallow fish much larger than their neck (esophagus) appears, but it must be swallowed headfirst due to scales and fins. When a parent returns to the nest and regurgitates a fish for its young, the adult goes through many gyrations to bring forth the food; nonetheless, it apparently does so without any injury.

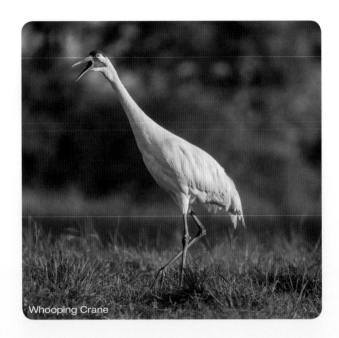
Whooping Crane

WHAT'S THAT SOUND?

Cranes, herons and egrets don't make beautiful musical sounds or sing songs to impress a mate or claim a territory, like songbirds. Instead, they produce primitive calls or a series of guttural grunts, croaks and groans to communicate in various ways. For example, when a Great Blue Heron is startled or frightened, it takes off with a loud croak followed by a series of grunts, indicating displeasure. Honestly, it sounds prehistoric to me.

Most herons and egrets sound similar, but there are enough differences to identify each species by its call. The Great Egret, for instance, utters a loud, low-pitched croak, sounding almost like a snore. In the evening, egrets often roost together in safe spots. When they arrive at a site, they pick a branch to spend the night. If one lands too close to another, often a battle of throaty voices occurs, sometimes getting very loud.

Night-herons and Green Herons issue primitive calls when upset, disturbed or squabbling with neighbors at communal nesting sites or individual roosting spots. Adult Green Herons repeat a sharp "skyew" call. Juvenile Green Herons in the nest give a strange ticking call that sounds like a ticking clock.

Sandhill and Whooping Cranes also deliver primal calls, but the sounds of the Sandhill seem especially fitting for this ancient bird. Its guttural calls sound more like old, rattling bones. Whoopers sound much different, giving extremely loud, high-pitched, trumpet-like calls. Usually one or two adults sound off at a time.

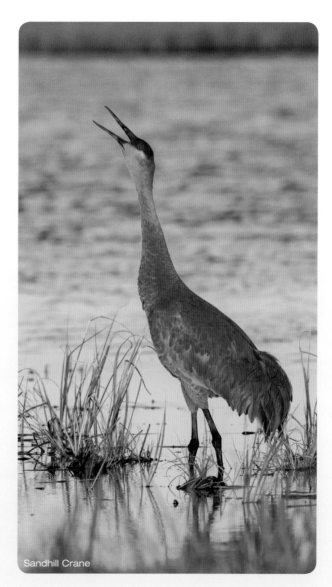

Sandhill Crane

83

Great Egret

84

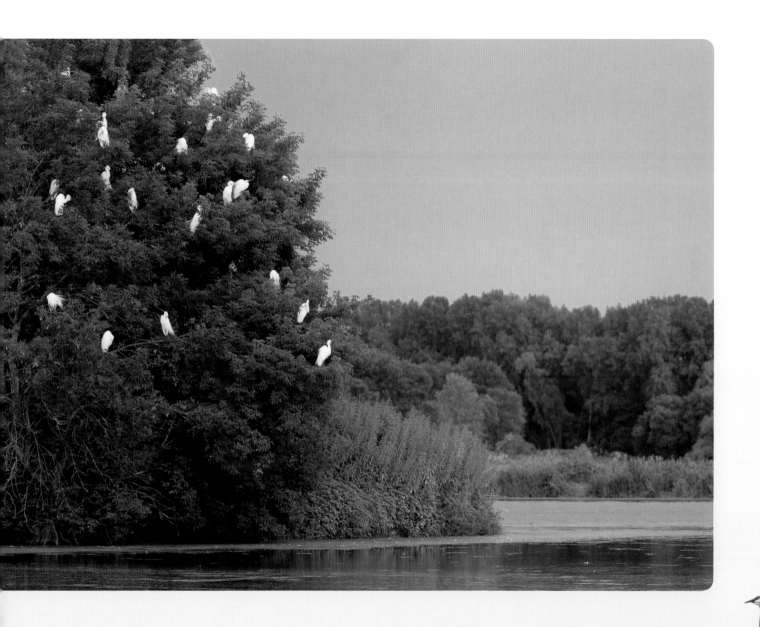

THE DEAFENING CALLS OF THOUSANDS

Cranes have the longest trachea in the bird world, and it pumps out sound like the twisting, turning tubes of a trumpet. When a crane belts out its call, the sound can be heard as far as a mile away.

When thousands of Sandhill Cranes gather in one spot, the combined calls can be deafening. I recall many hours in my cramped, tiny nylon blind on the banks of the Platte River with nearly 20,000 of these birds directly in front of me and all calling at the same time—or at least it sounded that way. Worse yet, they called nearly all night long, keeping me awake except for the last hour or so before sunrise.

There was another time when I was in a 4x6-foot wooden box blind in the middle of a "morning loafing" area with 10,000 Sandhills calling on all sides. In both of these experiences, I could not believe just how loud groups of cranes can be! It's a sound I'll never forget and one that I associate with many happy times.

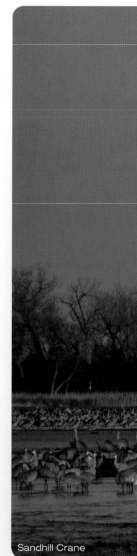

Sandhill Crane

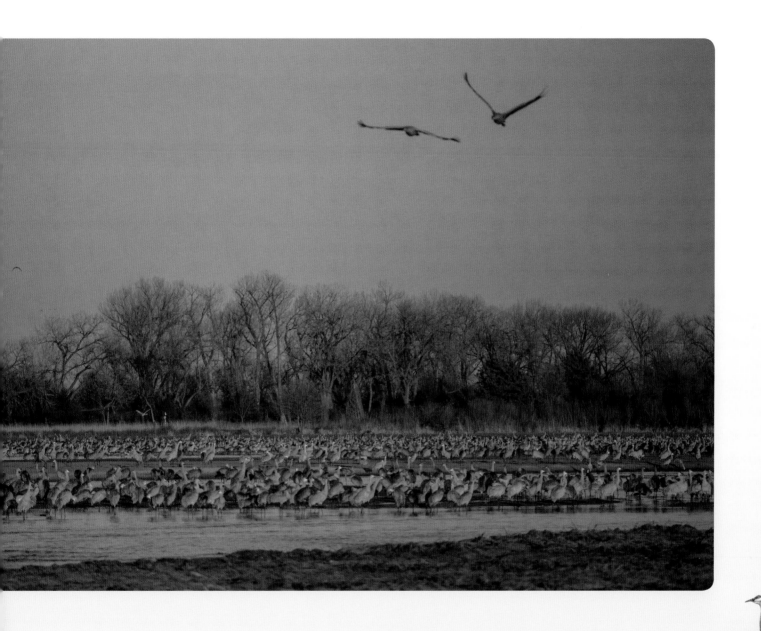

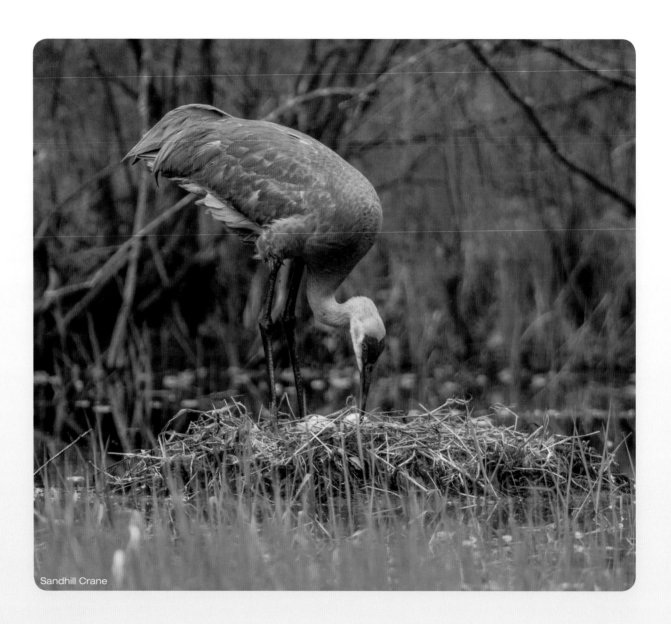

Sandhill Crane

BUILDING THE NEST

Cranes nest alone. Usually they prefer wetlands, choosing a spot surrounded by fairly deep water. Water helps protect nesting cranes from foxes, coyotes and other predators that don't like to swim. Also, nesting in an open area provides them with a view to clearly see approaching threats.

A crane constructs its nest solely with native wetland plants growing nearby. The nest can be upwards of 3 feet wide, but the trick is to make it tall enough so if there is localized flooding, the eggs won't wash away.

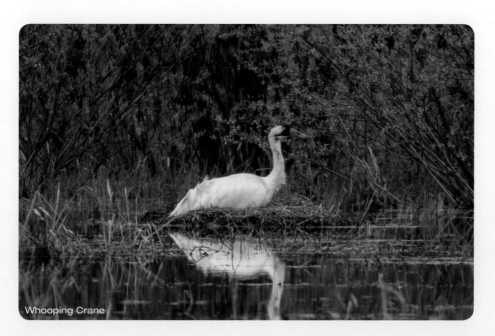

Whooping Crane

Herons and egrets are not master builders. They take a more-is-better approach and keep adding more sticks to the nest until it holds a shape without falling apart. Afterward, they pull grasses and other smaller, finer plants to line the interior. Often, they reuse their nests year after year and continually add branches, resulting in very large nests over time. These nests are usually in large colonies with up to several hundred nests.

Some heron species, such as Green Herons, nest by themselves. They make a small platform of twigs and sticks in a tree that ranges 3–30 feet high. Sometimes they build directly over water; other times they pick a site nowhere near it. Like many nesting birds, Green Herons tend to be fairly secretive and often go unnoticed until the young birds start climbing around on branches, begging for food.

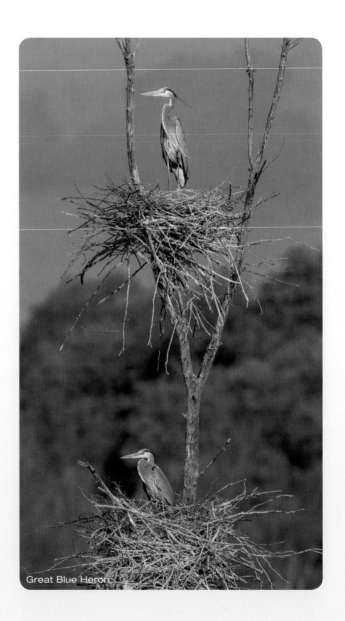
Great Blue Heron

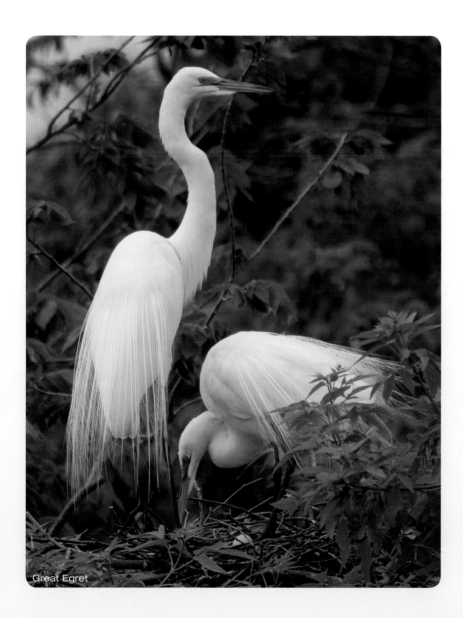

Great Egret

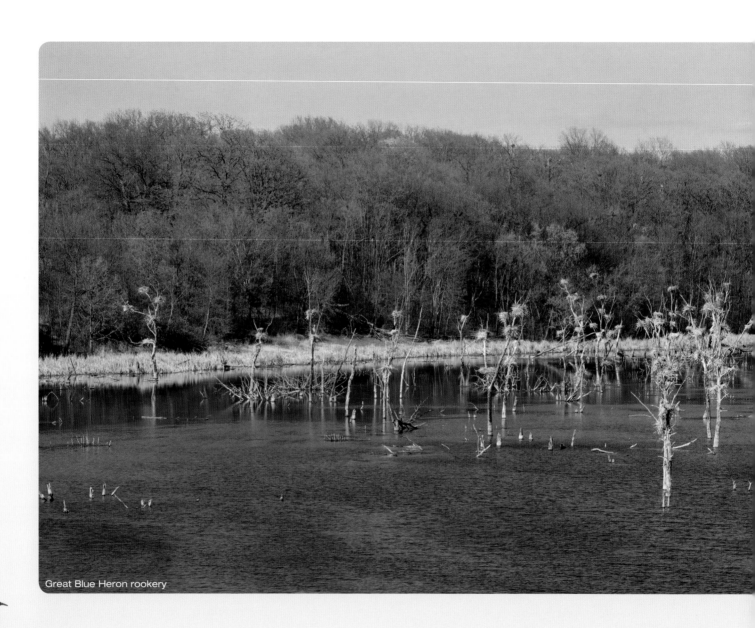

Great Blue Heron rookery

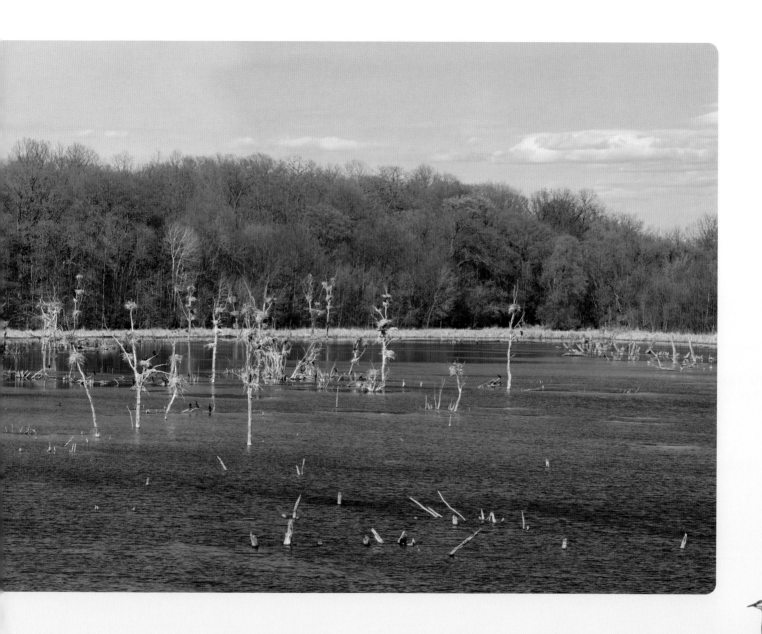

THE NEIGHBORHOOD

When a group of herons nests together, it's called a heronry. This is a specific term that describes herons nesting in one colony. Many times heronries have more than one species of nesting herons.

The term "rookery" is also used but is less specific and can refer to many other bird species nesting together. Often Great Egrets and other egret species will join the herons in their nesting colonies. Cormorants and even Great Horned Owls also nest in these rookeries.

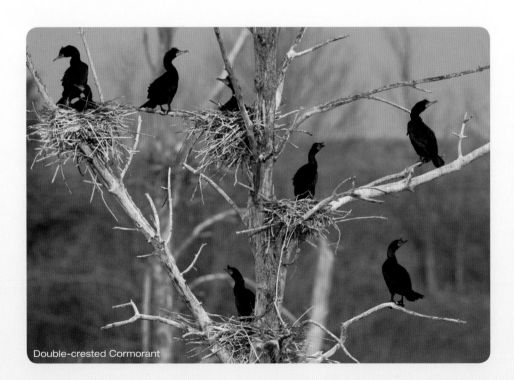

Double-crested Cormorant

Some heron and egret species nest in huge colonies, with hundreds of pairs together in one communal area. Oftentimes, pairs of herons nest in the same tree, resulting in two, three or sometimes more nests in one tree. Many times they nest in dead or dying trees. A group of trees that have died due to flooding is a choice spot for a heronry or rookery. Islands in small bodies of water are also favored sites. Sometimes the birds nest in live trees, but over time the nesting activity often kills the trees.

PAIR BONDS AT NESTING SITES

The drive to mate, reproduce and care for young is very strong in cranes, herons and egrets. Studies show clear evidence that these birds have long-term pair bonds. This means that pairs will usually stay together for many years for the purpose of mating.

Generally, if a Sandhill Crane population is widespread enough so that different pairs of cranes are not interacting with one another, mates tend to stay together. When nesting pairs successfully reproduce young, it strengthens the bond between the mates, making them more likely to remain with each other. However, if a nesting attempt fails for any reason, pairs are apt to find other mates or move to another territory.

Studies also reported that when populations of nesting cranes are in close proximity, about three-quarters of the breeding birds switched partners many times over a 15-year period. Rivalry for the best mate, competition for the best territory, nest failure and more contribute to partner swapping.

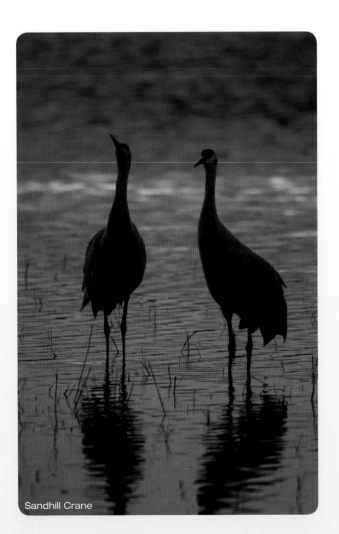

Sandhill Crane

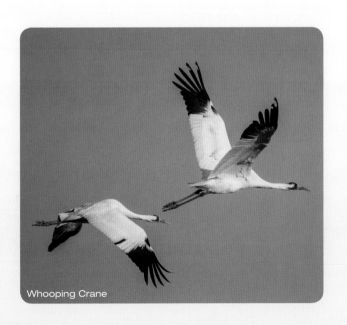
Whooping Crane

Prime nesting spots also influence mate selection and retention. When nesting spots are at a premium and hard to find, Sandhills and Whoopers change partners more often. Males compete with other males for the best nesting spots, while the females often stay in the nesting territory. Sometimes, if a female can garner a better nesting spot from another female, she will take over that site along with its male.

In areas where pairs are spread far and wide and there isn't much competition for prime nesting spots, Sandhills tend to have especially long pair bonds. It is important to remember that it is not societal pressure that influences these birds—rather, it is the desire to successfully reproduce at any cost.

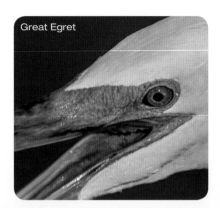
Great Egret

PLUME SHOWS

In herons and egrets, courtship is all about showing off elaborate feathers and, in some cases, exaggerated skin colors. The Great Egret is a prime example of these characteristics. When the breeding season approaches, the Great Egret grows long, beautiful plumes. These create an impressive sight when they are fanned out and flaunted in display.

In addition, the skin just behind the bill, called the lore, turns vibrant green. Displaying fancy feathers and brightly colored skin shows that the bird is healthy enough to produce strong offspring and would make a good mate.

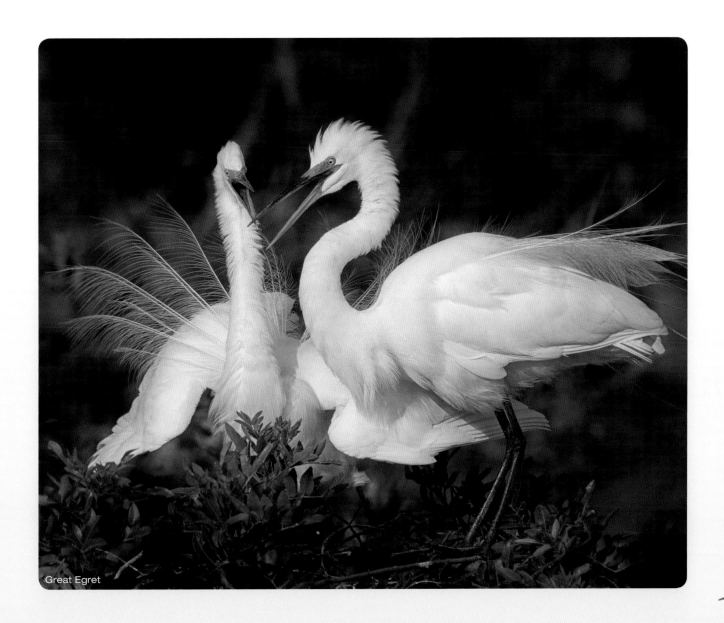

Great Egret

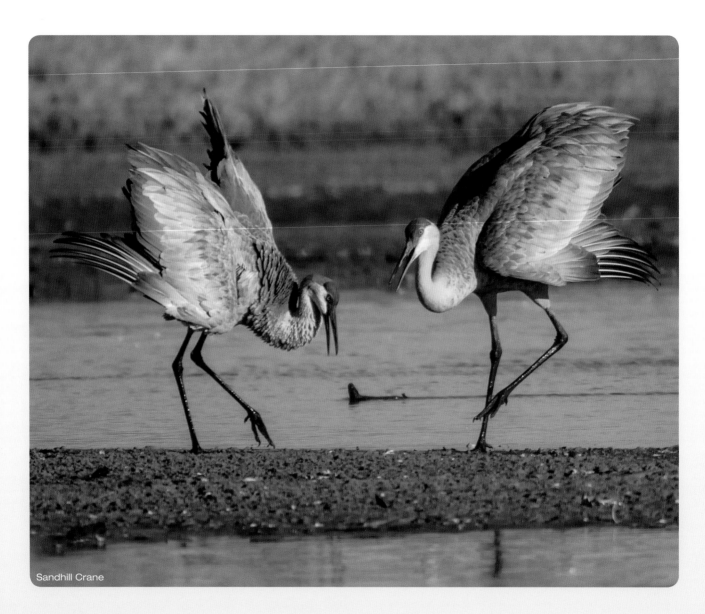

Sandhill Crane

100

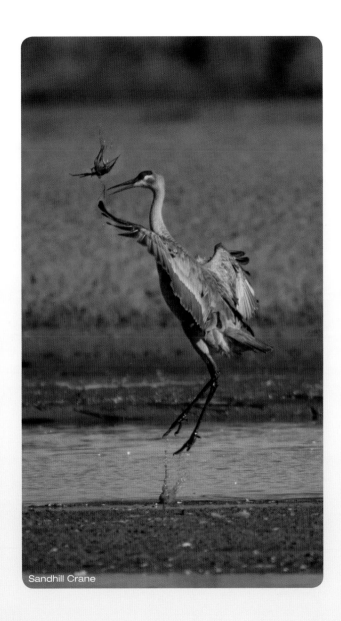
Sandhill Crane

SPECTACULAR COURTSHIP DANCING

To show their affection for one another, crane pairs will dance. Starting late in winter and early spring, pairs face each other, bob their heads, spread their wings and decorously bow, lowering their heads to the ground. After presenting themselves, they bounce straight up into the air, flapping and throwing their heads to the sides as visual displays to each other. Often during the dance, the birds reach down to grab a tuft of dried grass or a stick and toss it into the air. They also loudly call back and forth to each other while dancing—both partners seem to enjoy this a lot! This spectacular mating ritual can go on for up to a minute.

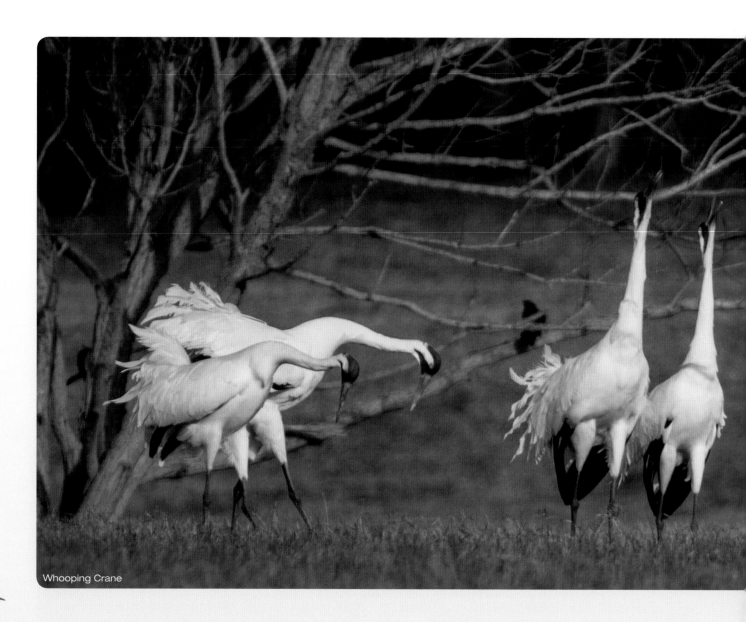

Whooping Crane

MATING BEGINNINGS

In general, the larger the bird, the longer the life span and time it takes to mature and start mating. Accordingly, our large Whooping and Sandhill Cranes don't reach maturation and begin to breed until 3–4 years of age. The first attempts at nesting are typically unsuccessful, usually due to lack of experience. So young couples frequently break up and find other mates. This goes on until they successfully reproduce. After this, they often remain faithful to their mate and nest site for many years.

The smaller herons and egrets take just a couple of years before reaching sexual maturity. Most Great Blue Herons start breeding in their third spring at 2 years of age, while some wait until their fourth spring at age 3. The same is true for Great Egrets and Black- and Yellow-crowned Night-Herons.

EGGS IN THE NEST

No matter their age, Sandhill and Whooping Cranes produce a maximum of two eggs. Sandhills have very large eggs that are off-white to olive-tan and heavily marked with brown.

Younger herons and egrets produce fewer eggs than more mature birds. The overall health of adult females determines how many eggs will be produced. The nutrients necessary to make an egg come directly from the mother's body, so if she is in poor physical condition, she won't lay a full clutch. For example, a Great Blue Heron can produce anywhere from two to six eggs during the nesting season, with an average of four per clutch. Also, they nest only once per breeding season. If, for some reason, they lose their eggs or babies, they don't renest. They must wait until the next year to try again.

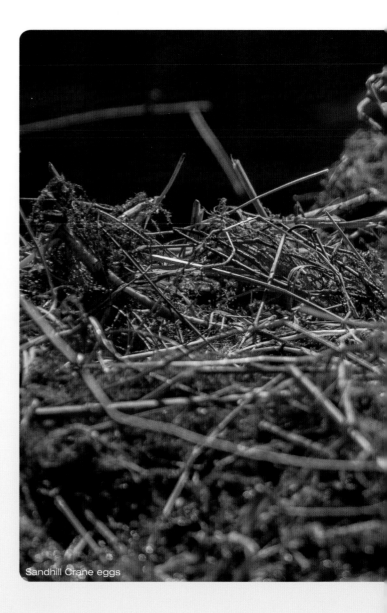
Sandhill Crane eggs

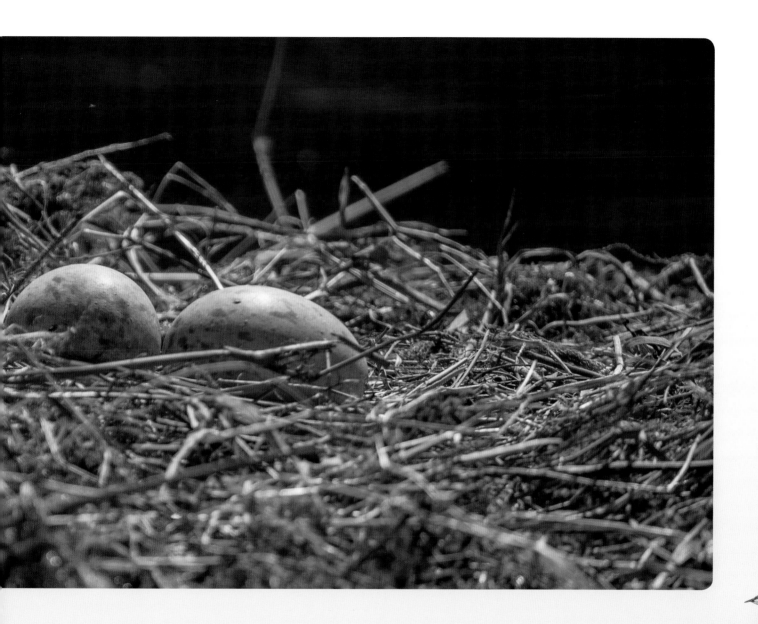

A MONTH OF INCUBATION

Cranes are the picture of cooperative parents. Incubating duty goes on nearly round-the-clock and is split almost equally between the parents for about a month. When one bird is away feeding, preening or stretching its wings, the mate cares for the eggs. Parents also often add more nesting material at this time, pulling in tiny sticks or plants.

Heron and egret parents take turns incubating as well. When one parent flies in, the other quickly takes off. The arriving bird often stands around the rim, inspecting the nest and making adjustments before settling down. Usually parents alternate every couple hours. Like cranes, most heron and egret species incubate for a month or so.

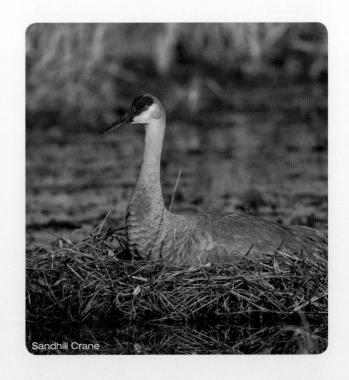
Sandhill Crane

Imagine sitting in one spot for a month! We barely give a thought to the critical balance of temperature, ventilation, sanitation and egg position that is needed to incubate successfully. Incubation is actually an amazing feat and hard to appreciate until you try duplicating it. I've incubated many species of eggs in a high-tech incubator and, unlike birds, I struggle to get all the eggs to hatch every time.

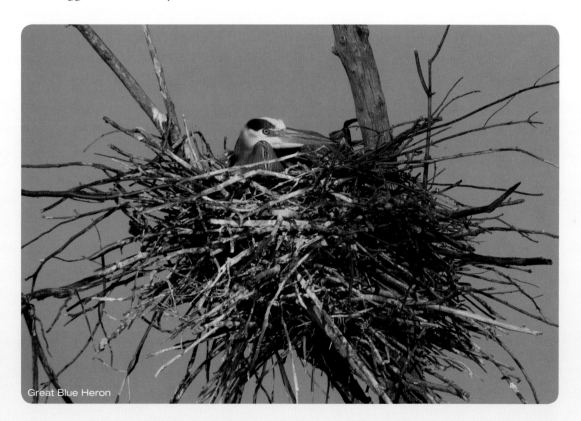
Great Blue Heron

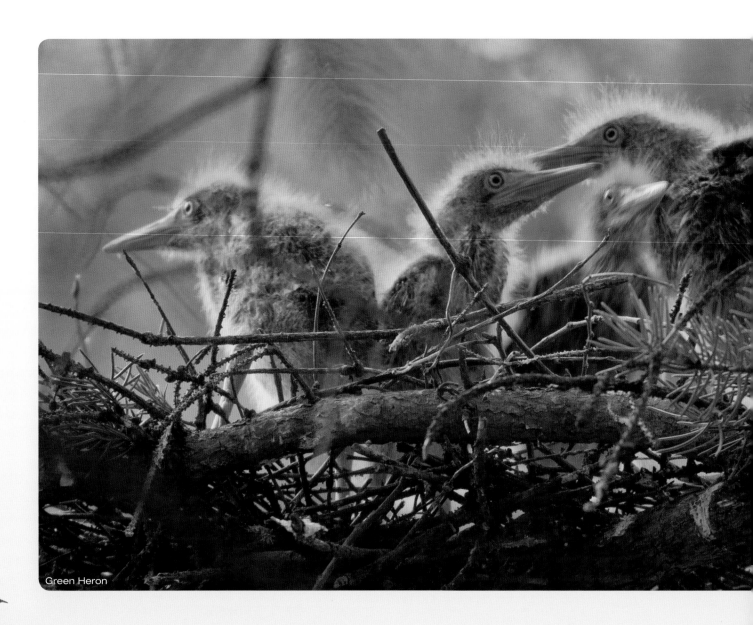

Green Heron

THE CHICKS ARE HATCHING!

Cranes lay their two eggs 24 hours apart. They start incubating immediately after the first egg is laid, giving it a head start toward hatching. Sometimes the second egg catches up and both hatch at the same time.

Because herons and egrets usually lay more eggs than cranes, hatching is a slower process that can take one to several days. Herons can produce upwards of six eggs, so the hatching process can take six days or more.

All bird species can lay only one egg per day, and some lay eggs every other day. In herons and egrets, as soon as the first egg is laid, the parents begin incubating. So the first egg laid will be the first egg to hatch. If it takes six days to lay a clutch, then usually it takes six days for all the eggs to hatch. Because each egg has the same incubation requirements, sibling chicks will vary in age. Unfortunately, older siblings typically harass and even attack the youngest sibling, often with disastrous results. I have witnessed this many times and find it difficult to watch every time.

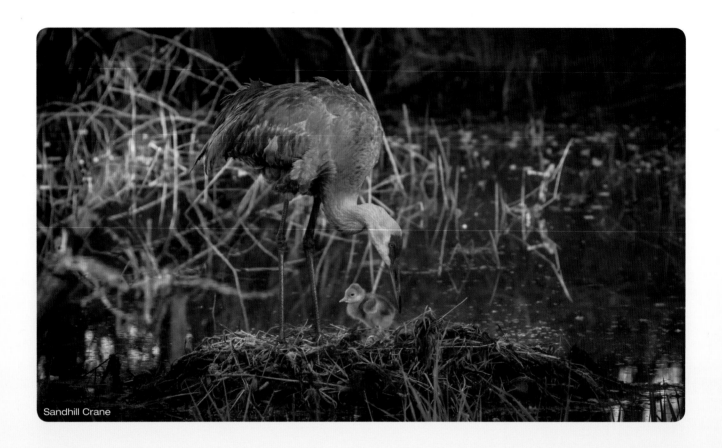

Sandhill Crane

WARMTH IN THE BROOD

When heron and egret chicks hatch, their eyes are sealed shut and they are only sparsely covered with feathers. In addition, their thermal regulating system is not functioning yet, and they can't keep themselves warm. So the parents sit on the newly hatched babies in a process known as brooding. This keeps all the babies, called the brood, safe and warm underneath. Brooding can continue for upwards of a week before the babies have developed enough feathers and muscle control to stay warm without sheltering beneath the parents.

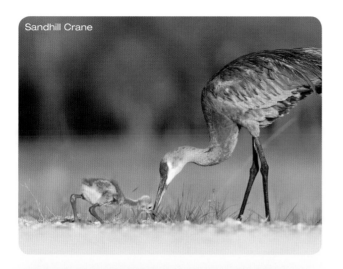

Sandhill Crane

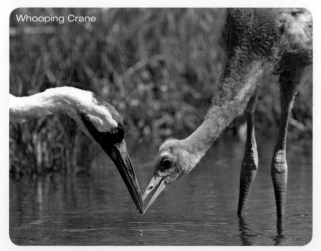

Whooping Crane

Sandhill and Whooping Crane babies hatch with a full coat of feathers and eyes and ears open. After quickly learning to stand up, crane babies are ready to swim and walk. They are all set to leave the nest within 24 hours of hatching, and at that time the entire family moves out into the world. The chicks won't ever go back to the safety of their nest, but the parents will return to reuse it during the next breeding season.

Most crane nests are located in water. After the initial swim, the babies walk around, following their parents and begging for food. Both parents snatch up small insects and seeds to feed to their young, which are called colts. The colts follow their parents for nearly the entire spring and summer before they learn to fly.

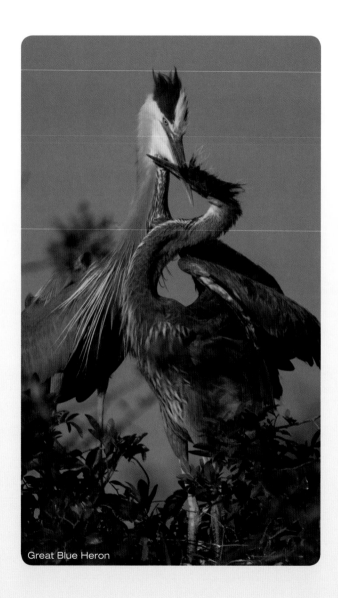

Great Blue Heron

ROWDY BEGGING MATCHES

After hatching, life for baby herons and egrets is quite different from that of crane chicks. In herons and egrets, early life is all about the nest, begging for food and competing for it. At first the young are too weak to do much begging or contending. The parents go hunting for fish and return with full loads. The babies beg, and the parents respond by regurgitating fishy meals.

As the chicks grow and gain more control of their muscles, the begging escalates physically. All the chicks try to grab the bills of their parents to get food and pull madly in a wild grabbing and pulling match. I have watched young Great Blue Herons grab a parent's bill and pull so hard that they nearly knocked over the adult!

An adult with a full gullet of fish goes through several contortions, then lowers its head and out comes a number of fish. The young squabble and fight over the offerings, quickly seizing and swallowing any morsel they can get. Both parents go fishing repeatedly and return to feed the babies many times a day. Once they drop off the food, they perch on a branch away from the nest or fly away.

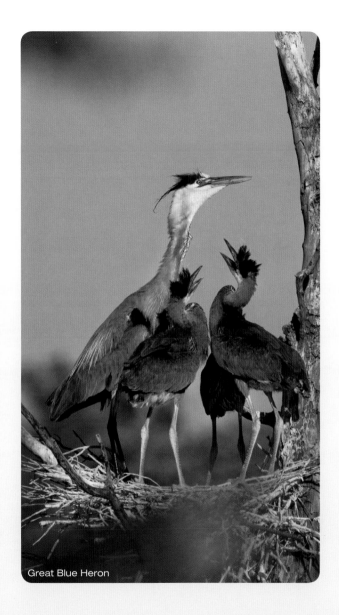
Great Blue Heron

SIBLING AGGRESSION IN THE NEST

Great Blue Heron chicks are often aggressive toward each other and fight violently over food while still in the nest. Fighting with their long, sharp bills often leads to the youngest or smallest bird falling out of the nest or getting pushed out.

Many times while photographing an adult returning to the local rookery with a load of fish, I have seen the youngest baby avoid being viciously attacked by its older siblings by hanging its head over the side of the nest as if dead and waiting for the feeding to end. Presumably it would get just the food scraps that remained, but at least the baby didn't get thrown out or fiercely assaulted. From what I have witnessed, though, this playing-dead behavior works in the short term but often is just a prelude to what is yet to come.

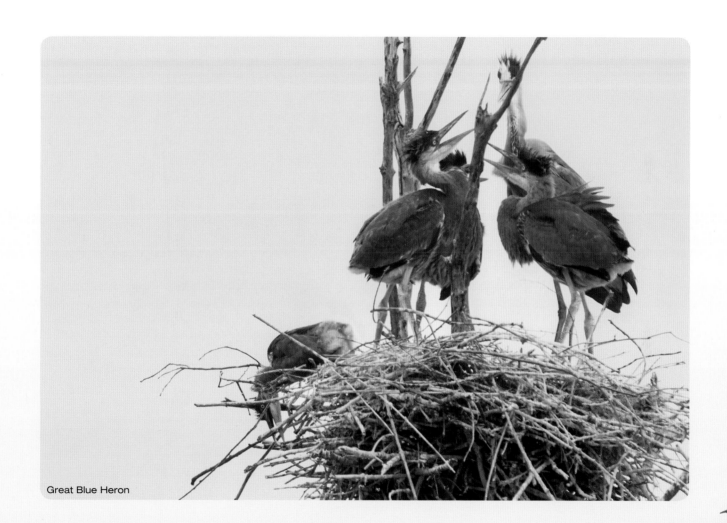

Great Blue Heron

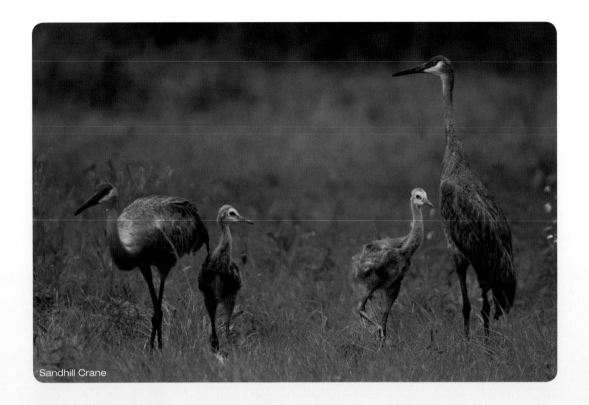
Sandhill Crane

SURVIVING THE PERILS

From sibling rivalry to predators and disease, the beginning of life for all birds is perilous. Depending on the species, the survival rate of newly hatched chicks is just 40–60 percent. Perhaps this is why herons and egrets have so many offspring.

Cranes have a reproductive success rate of about 50 percent, which means only one of the two young will make it to adulthood and reproduce. A pair of cranes will thus need two successful breeding seasons to replace themselves and a third year to actually add to the overall population.

When four or more chicks are in a heron or egret nest, generally 40–50 percent won't make it to one year of age. This illustrates how difficult and demanding life is for these young birds. What's more, because adult herons and egrets don't live as long as adult cranes, they don't have as many years to reproduce and replace themselves or increase the population.

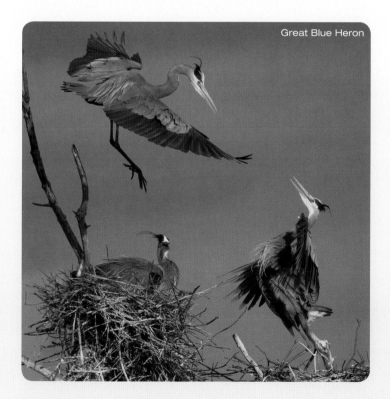

Great Blue Heron

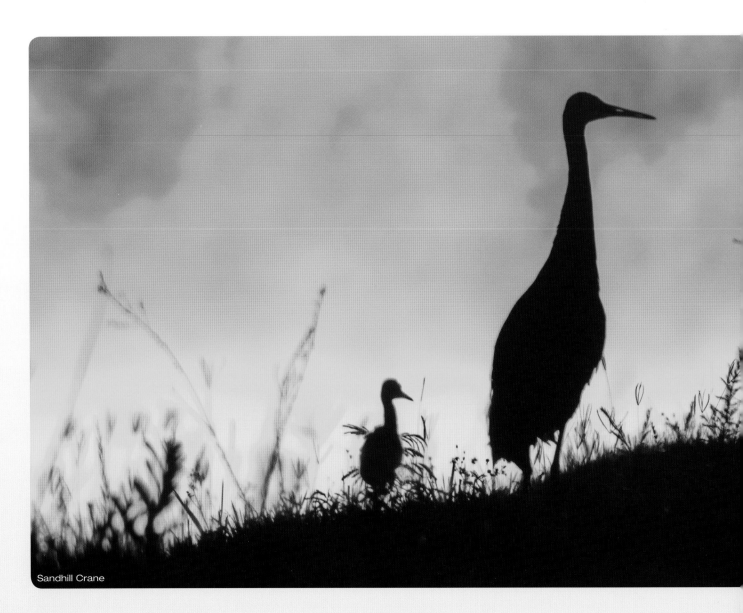

Sandhill Crane

GROWING INTO FLEDGLINGS

Once heron and egret babies grow larger, they can swallow larger food items. With bigger servings to digest, they don't need to eat as often, and parents start making fewer visits to the nest. I've heard people mistakenly say that the adults are with-holding food at this time to force the chicks out of the nest. This is simply not true. Chicks will leave the nest and fly when they are ready, just as young children will get up and walk when they are able. We don't withhold food to make our toddlers walk, and the same holds true for these birds.

The process of leaving the nest is called fledging. Once a young bird has vacated the nest, the bird is called a fledgling. Tricolored Herons and Snowy Egrets take a short 30 days to leave their nests. Little Blue Herons and Reddish Egrets fledge at 40–45 days. Great Blue Herons remain in the nest the longest, spending 55–60 days there before becoming full-grown fledglings. Usually once herons and egrets have fledged, they don't return to the nest.

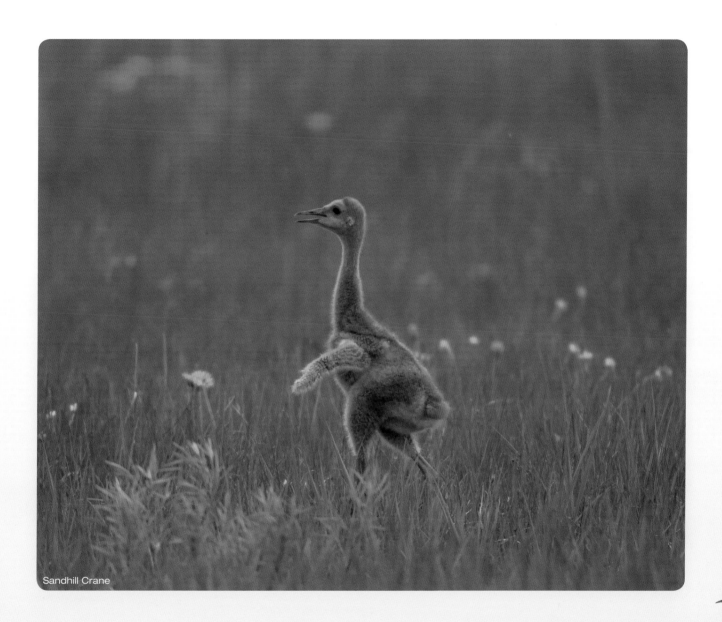

Sandhill Crane

THE FIRST FLIGHT

Crane colts walk around with their parents for two months before they are ready to take their first flight. Near the end of summer, at about 65 days of age, young cranes have grown to nearly adult size and have adult feathers. They spend a lot of time stretching their wings and building flight muscles. The design of their large, plump bodies perched atop their long, twiglike legs seems to defy lift, but one day they will turn into the wind and take a short run before taking off and rising into the air.

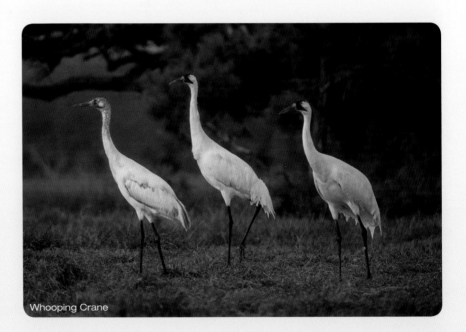

Whooping Crane

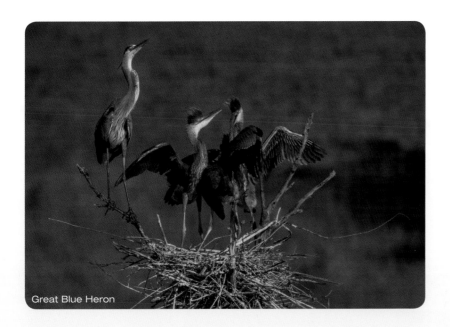
Great Blue Heron

Learning to fly comes naturally to cranes, herons and egrets. Flying is innate and not taught by the parents. The first flight of young herons and egrets is often from the nest to a nearby tree. Leading up to this, they frequently stand at the edge of the nest and flap their wings, exercising their muscles. Depending on the proximity to other trees, the first flight can be just a few feet or much longer.

Young birds that nest over water often experience a water-landing when first attempting to fly and are forced to swim or walk to shore. It may take two or three days before they are flying well enough to get where they want to go. The early days of flight attempts are more difficult for grounded young because they are openly vulnerable to predators. Young that manage to stay in the trees are more protected.

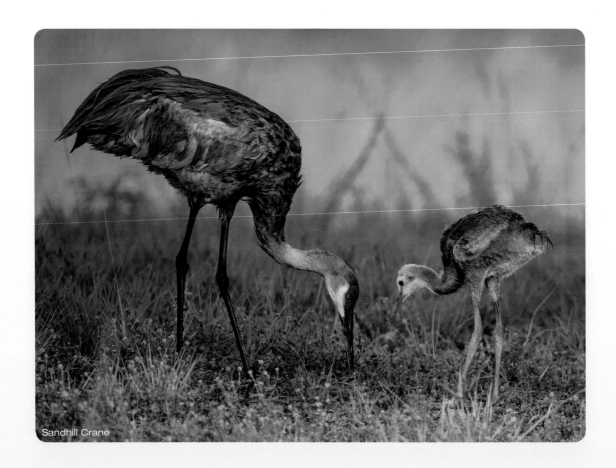

Sandhill Crane

HUNTING SKILLS

Hunting also requires some practice. Youngsters learn what to hunt by watching their parents. Most hunting behavior is inherent, and young birds start hunting right away. With time and practice, they quickly get the hang of it.

GATHERING INTO FLOCKS

After summering in family units scattered across large areas, Sandhills often congregate in refuges with good habitat. Feeding in groups of 20 birds or more, they return to the safety of their roosting areas in the evening. Usually these are sizeable wetlands where thousands of birds assemble. In the fall, large groups utilize their wetlands as a deterrent to predators and spend the nights together. When autumn draws to a close, huge flocks migrate southward to established resting areas on the way to their wintering grounds.

Herons and egrets tend to migrate singly or in small groups. They are independent and don't rely on safety in numbers.

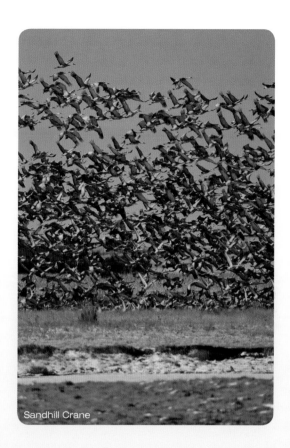

Sandhill Crane

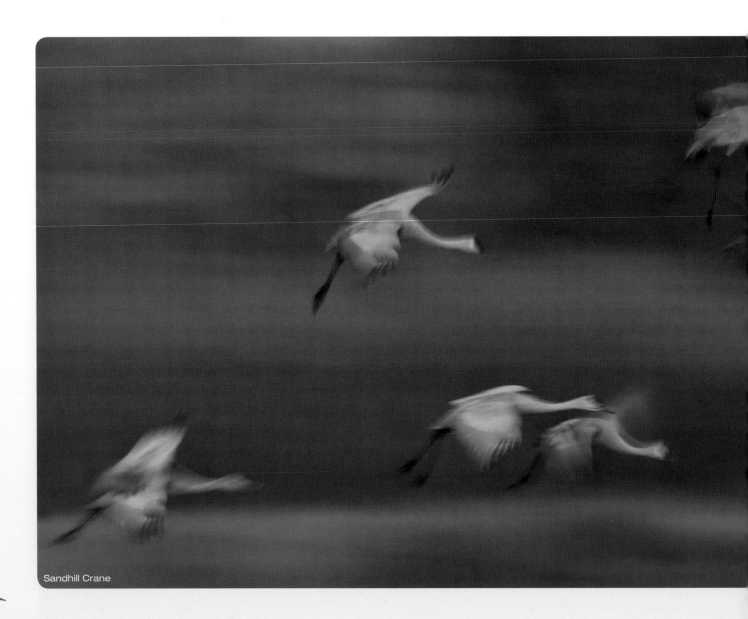

Sandhill Crane

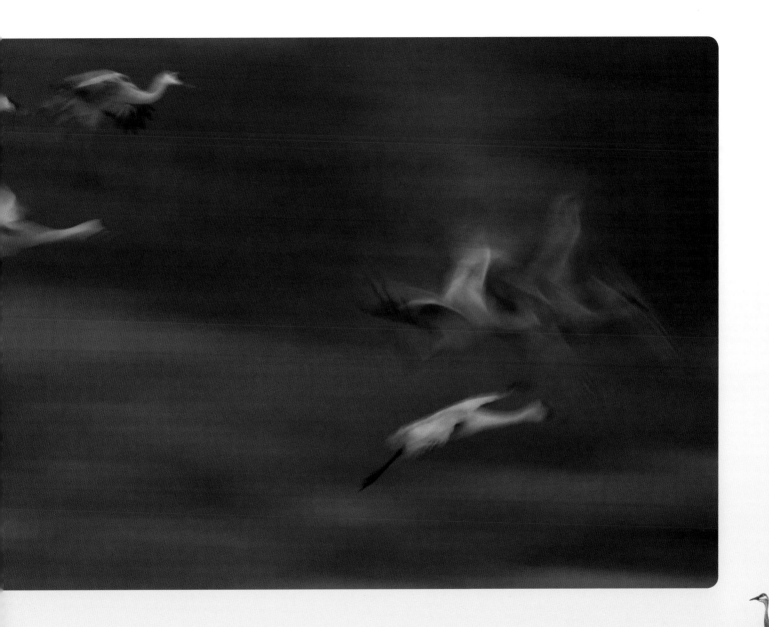

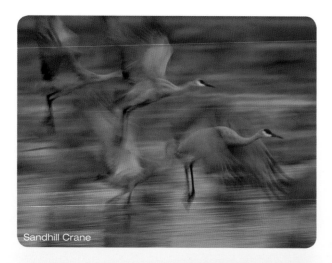
Sandhill Crane

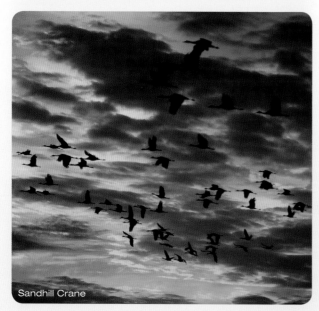
Sandhill Crane

THE URGE TO MIGRATE

No one knows when, where, how or why migration first started. We do know, however, that it does not result from a change in weather or a reduced food supply, but that it is triggered by the photoperiod—the amount of daylight from sunrise to sunset. In autumn, days get progressively shorter. The reduced length of daylight is perceived by birds and activates the release of hormones. These hormones make birds restless and prompt the urge to migrate. Birds don't have a choice whether or not to migrate. They are simply following their instincts, regardless of the prevailing weather or food supply.

Sandhill Cranes travel on average 25–35 mph during migration and usually cover 200–300 miles per day. When there is a good tailwind, however, they can reach 50 mph and journey 500 miles in a day. The western population even migrates over several mountain ranges and flies as high as 28,000 feet! Cranes make their way southward slowly, as the fall migration to wintering grounds is not particularly urgent.

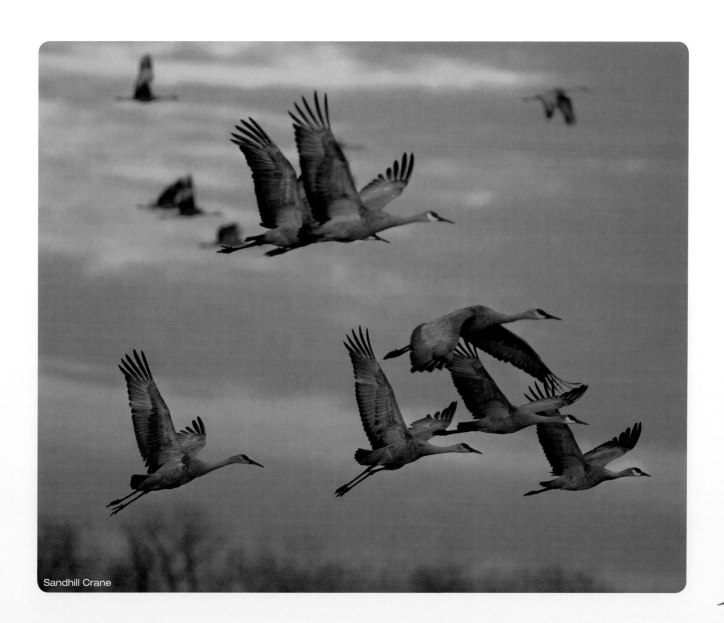

Sandhill Crane

WINTER'S REST

Cranes, herons and egrets fly south in the fall but don't breed in winter. Winter is the time to rest and feed. Although the non-migrating populations build nests and reproduce, the vast majority of birds migrate to mate elsewhere. Both migrators and non-migrators have only one chance to reproduce annually.

Many herons and egrets start establishing mating partners during winter. Sandhills often select mates from their huge wintering flocks and migrate back with them. They strengthen their pair bond along the way by dancing and staying together. This helps keep the bond strong through the breeding season.

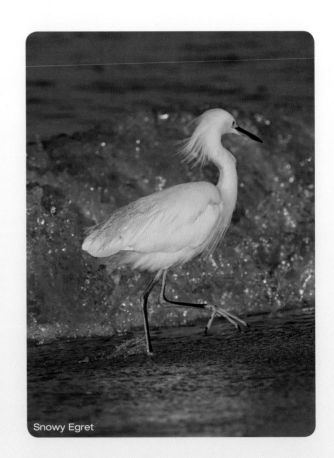
Snowy Egret

THE RACE HOME

The migration of cranes, herons and egrets is nothing short of spectacular! As spring days grow longer, the birds get the desire to migrate. Driven by hormones, they travel prehistoric flyways from their traditional wintering grounds to their breeding grounds.

Migration in autumn may be a slow process, but in spring it's more like an outright race. The first birds back to the best nesting grounds win! On arrival, cranes fight for territories with the most nutritious food and safest places to nest. The first herons and egrets to return get to claim the best nesting spots in their colony.

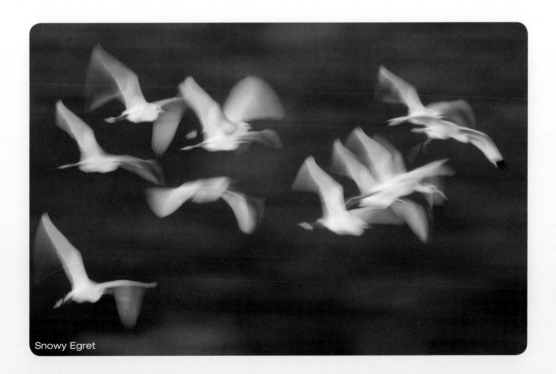
Snowy Egret

BACK AT THE PLATTE

Each spring, hundreds of thousands of Sandhill Cranes move out of their wintering grounds and bottleneck down to a 75-mile stretch of the Platte River in south central Nebraska. Starting in late February and early March, flocks of hundreds at a time arrive in this region. It appears that this is an ancient pathway, dating back some 10,000 or more years.

In what can only be described as one of the most amazing spectacles in all of nature, upwards of 500,000 Sandhill Cranes, representing about 90 percent of all the Sandhill Cranes on the planet, gather along the banks of the Platte River. This event lasts just four to six weeks. During the day, the birds go into the surrounding countryside and feed on spilled grains from the previous farming season and natural sources of food. Each evening, they return to the security of the Platte sandbars, where tens of thousands spend the night.

Sandhill Crane

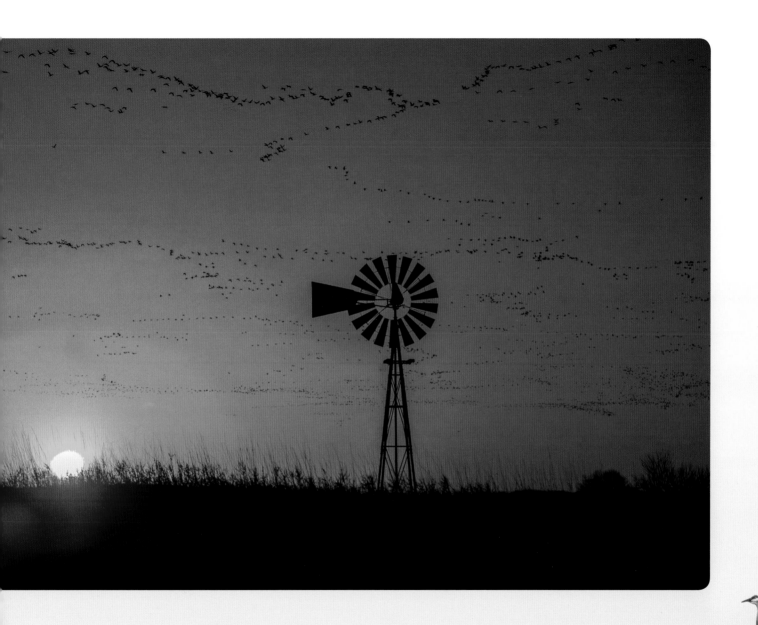

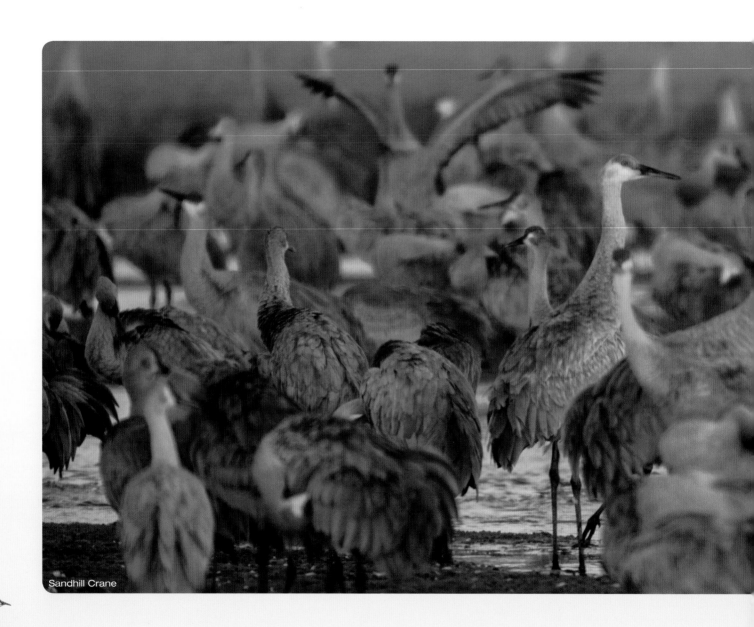

Sandhill Crane

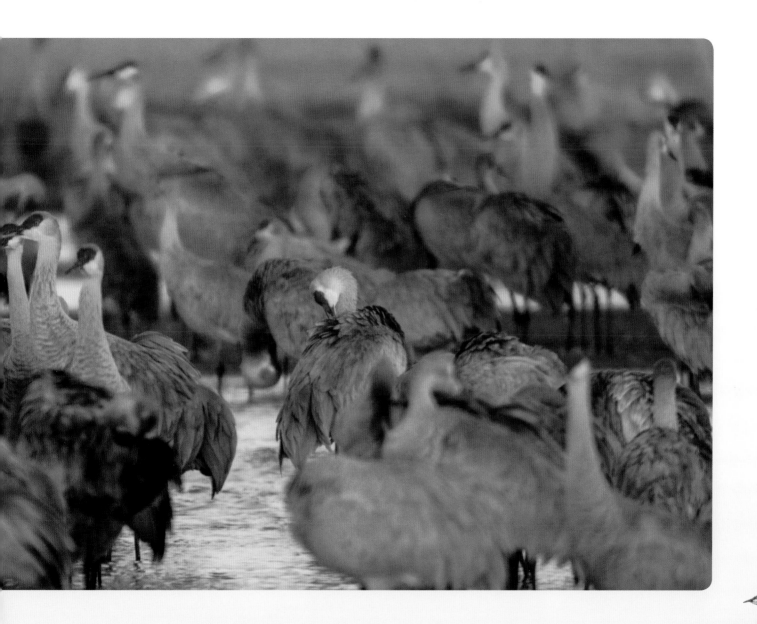

After gathering at the Platte, the cranes continue their journey northward. Some of these birds go only a few hundred more miles before settling down to nest. Others travel thousands of miles across Canada and well into Alaska before resting on their breeding grounds. Still others fly much farther, across the Bering Sea to Siberia, where they call Russia home.

Then, when autumn comes, the adults and their young—which are not even a year old yet—turn around and migrate all the way back to their wintering grounds in Texas, New Mexico, Arizona and California. Some will fly even farther, well into Mexico.

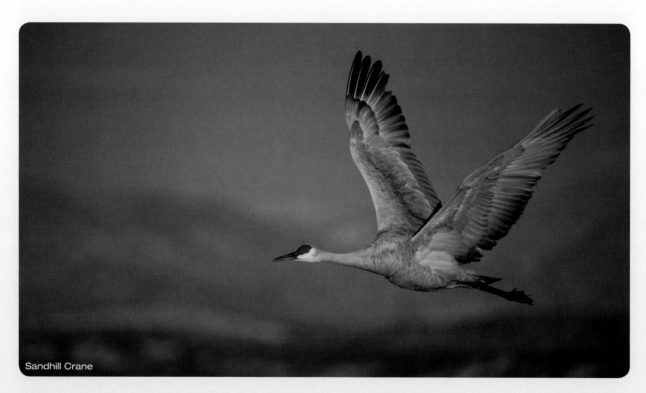

Sandhill Crane

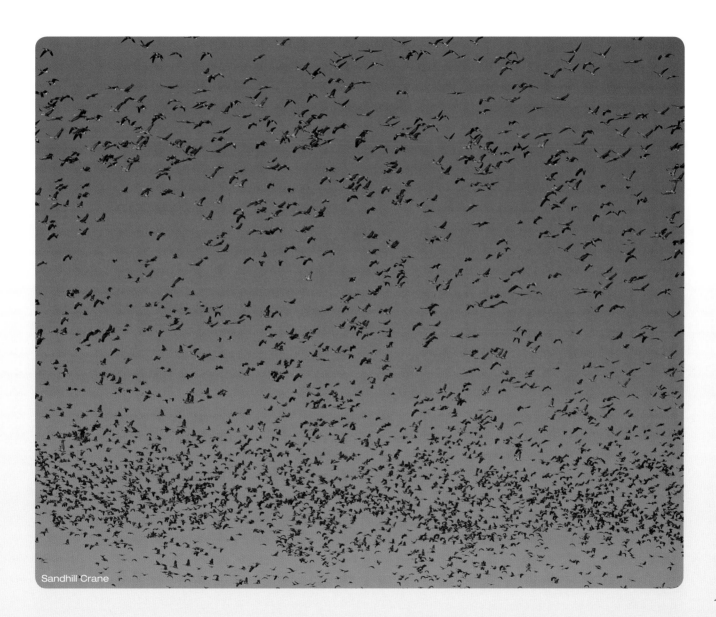

Sandhill Crane

137

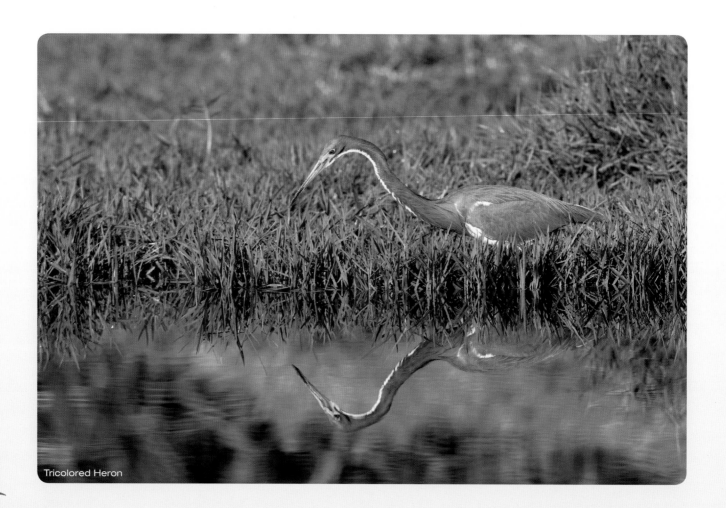

Tricolored Heron

OUR ELEGANT, TALL BIRDS

Cranes, herons and egrets are long-legged, elegant birds that are amazing to watch. Seeing them near our homes or while out for a walk or bike ride greatly enhances our outdoor experience. Because they tend to be tall, large, colorful and fairly obvious, we take much joy in being able to observe and identify them easily.

Cranes are the royalty of the bird world. No other bird represents such beauty, stateliness and grace. Since the dawn of time and across every nation on this planet, cranes have drawn the admiration of people. From their soul-touching call to their magnificent flight, Sandhill and Whooping Cranes adorn North America with their presence.

Herons and egrets are a diverse group of handsome wading birds. From the pure white Great Egret to the diminutive Green Heron, they all share the propensity for fresh fish. Chances are, you have seen some of these marvelous birds stalking ponds, lakes, rivers or backwaters in search of their next meal.

The power of nature reaches through these beautiful birds deep into our souls and touches a place that needs to be soothed. I am thrilled every time I see, hear or photograph a crane, heron or egret, and I feel fortunate to be able to study and appreciate these incredible birds! I sincerely hope that you appreciate them too.

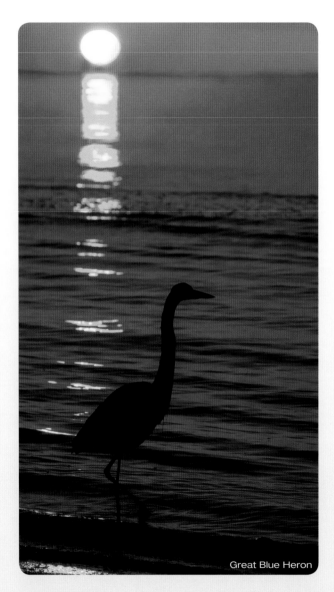

Great Blue Heron

This photo spread shows all 12 species of cranes, herons and egrets in the United States and Canada and their ranges. Like other birds, cranes, herons and egrets move around freely. For example, Snowy Egrets and Little Blue Herons, as well as Cattle Egrets, Great Blue Herons and Yellow-crowned Night-Herons, routinely wander well outside of their breeding ranges and especially north of the breeding ranges, but they are not migrating to breed. We have included these dispersals in the migration regions of our maps to show the occurrence of the birds in these areas. Please keep in mind, however, that the maps do not indicate the number of individuals in any given area (density).

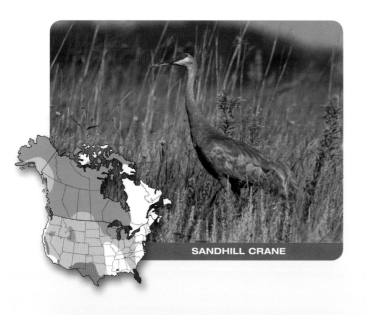

SANDHILL CRANE

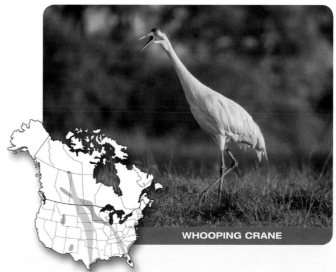

WHOOPING CRANE

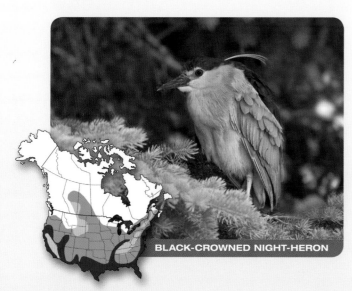

BLACK-CROWNED NIGHT-HERON

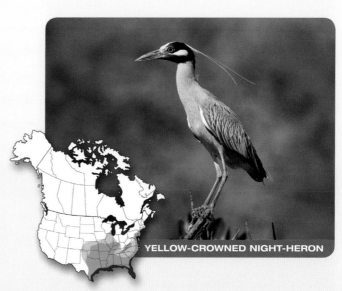

YELLOW-CROWNED NIGHT-HERON

KEY ● year-round ● breeding ● migration ● winter ● former range

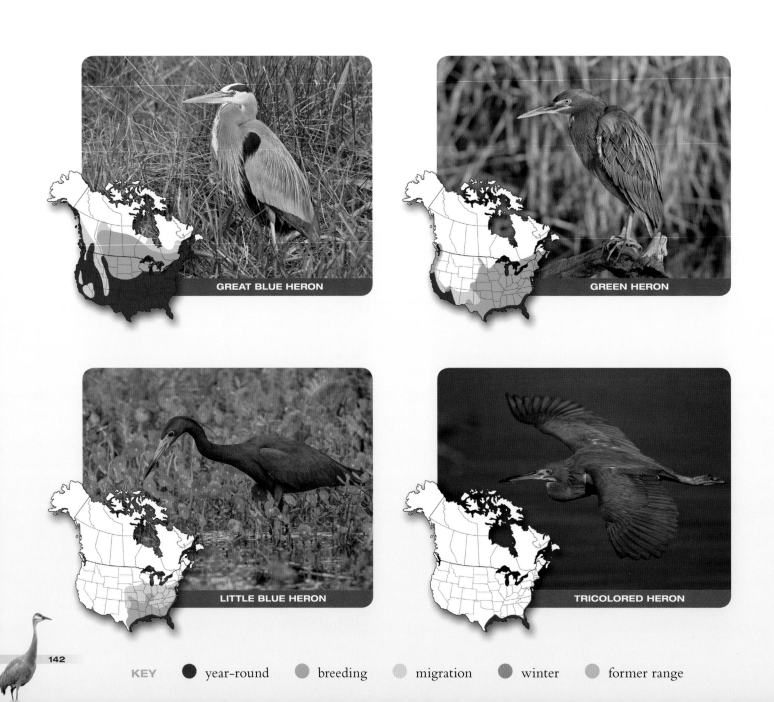

GREAT BLUE HERON

GREEN HERON

LITTLE BLUE HERON

TRICOLORED HERON

KEY ● year-round ● breeding ● migration ● winter ● former range

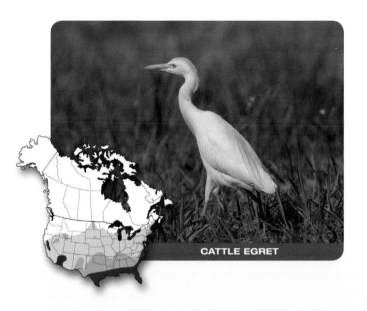

CATTLE EGRET

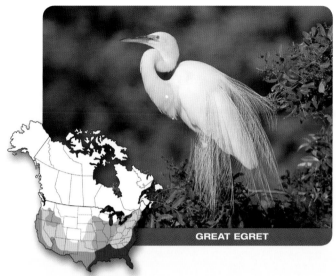

GREAT EGRET

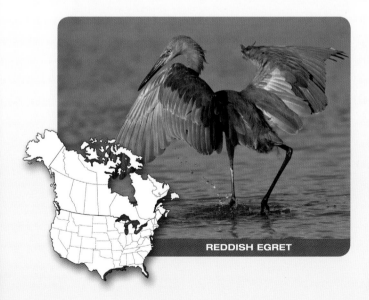

REDDISH EGRET

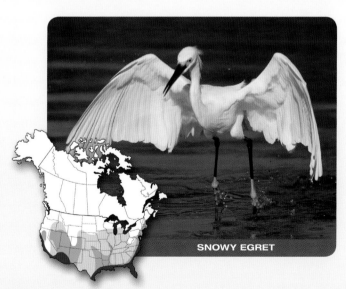

SNOWY EGRET

KEY ● year-round ● breeding ● migration ● winter ● former range

ABOUT THE AUTHOR

Naturalist, wildlife photographer and writer Stan Tekiela is the author of the popular Wildlife Appreciation book series that includes loons, eagles, bluebirds, owls, hummingbirds, woodpeckers, wolves, bears, deer and cranes. He has also authored more than 130 field guides and wildlife audio CDs for nearly every state in the nation, presenting many species of birds, mammals, reptiles, amphibians, trees, wildflowers and cacti.

With a Bachelor of Science degree in Natural History from the University of Minnesota and as an active professional naturalist for more than 25 years, Stan studies and photographs wildlife throughout the United States and Canada. He has received various national and regional awards for his books and photographs. Also a well-known columnist and radio personality, his syndicated column appears in more than 25 newspapers and his wildlife programs are broadcast on a number of Midwest radio stations. Stan can be followed on Facebook and Twitter. He can be contacted via www.naturesmart.com.